Valerie Jaudon

René Paul Barilleaux

Introductory essay by Anna C. Chave

Mississippi Museum of Art

Library of Congress Cataloging-in-Publication Data

Barilleaux, René Paul.
 Valerie Jaudon / René Paul Barilleaux; introductory essay by Anna
C. Chave.
 p. cm.
 Catalog of an exhibition held at the Mississippi Museum of Art.
 Includes bibliographical references.
 ISBN 1-887422-00-5 (pbk.)
 1. Jaudon, Valerie, 1945- —Exhibitions. 2. Painting, Abstract—
United States—Exhibitions. I. Chave, Anna. II. Mississippi
Museum of Art. III. Title.
ND237.J37A4 1996
759.13—dc20 95-40822
 CIP

Kathleen Schenck Row, Graphic Designer
Ginger Tucker, Editor
Beth Warren Turnage, Assistant Curator/Registrar
Elizabeth McRee, Curatorial Intern

Mississippi Museum of Art
201 Pascagoula Street
Jackson, Mississippi 39201

Valerie Jaudon

Contents

Mississippi Museum of Art

May 24 — August 3, 1996

Exhibition organized by René Paul Barilleaux

Valerie Jaudon exhibition and catalog are supported by the

Lila Wallace—Reader's Digest Fund.

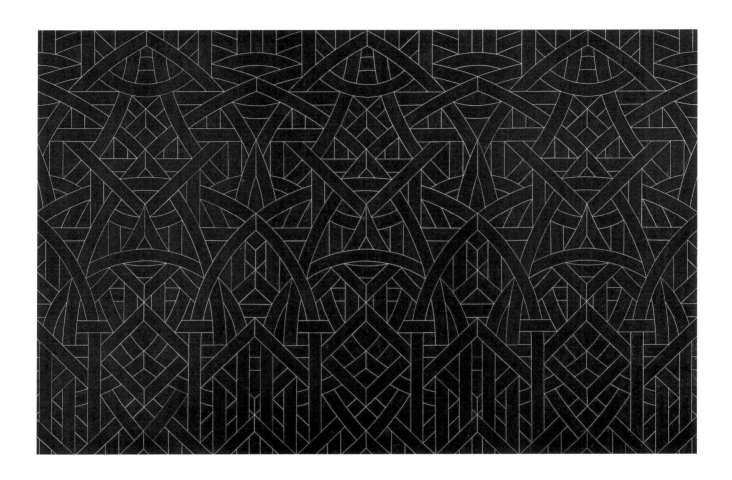

Valerie Jaudon, Hattiesburg,
1979, oil on canvas,
87" x 132".
Collection of Neue Galerie—
Sammlung Ludwig, Aachen,
Germany. (cover)

Foreword

René Paul Barilleaux
Director of Exhibitions and Collections / Chief Curator

Valerie Jaudon has emerged as one of today's significant abstract painters. Originally associated with the Pattern and Decoration movement of the 1970s, Jaudon's work evolved from its initial preoccupation with tightly structured, interlocking configurations into recent lyrical paintings with exotic compositions and shimmering surfaces. This exhibition and catalog are the first to explore fully Jaudon's art, systematically examining its evolution over two decades through thirty-three of her paintings and drawings. Additionally, this catalog is the first in-depth critical appreciation of her work as well as the most extensive source of information on the artist and her career to date.

As the largest art museum in Mississippi—and a primary repository of the state's visual art heritage—it is appropriate that the Mississippi Museum of Art organize a survey of the art of Mississippi-born Jaudon. A native of Greenville, she began her studies at the Mississippi University for Women prior to embarking on a journey that ultimately led to New York where she currently lives. By using the names of Mississippi towns as titles for earlier pieces, Jaudon lends an element of familiarity to them for the audience in her home state. At the same time, her work's ties to the emergence of abstraction in this century link it to both significant historical developments and larger global issues in art.

In the following essay, Anna C. Chave examines Jaudon's work not only in the context of its connections to that of other visual artists of her generation, but also draws into her discussion the influences of music and architecture on Jaudon's art. In doing so, Chave interweaves theoretical discourse on the major artistic movements of the 1970s with an exploration into the artist's own philosophy. Jaudon gives her own voice to this document in the form of an interview with the exhibition's organizer. A formal analysis of the conceptual and structural development of her paintings from 1973 through the present gives a clear overview of both major transitions and subtle shifts in their composition and surface, as well as some insight into Jaudon's working techniques.

Through this exhibition and catalog, Valerie Jaudon takes the viewer on an artistic journey, sometimes proceeding in enormous leaps and other times barely moving at all. Most significant, however, is not whether one takes the direct route or a meandering path, but rather that one experiences the force evident in Jaudon's art and comes to an understanding of this artist's belief in the power of visual language.

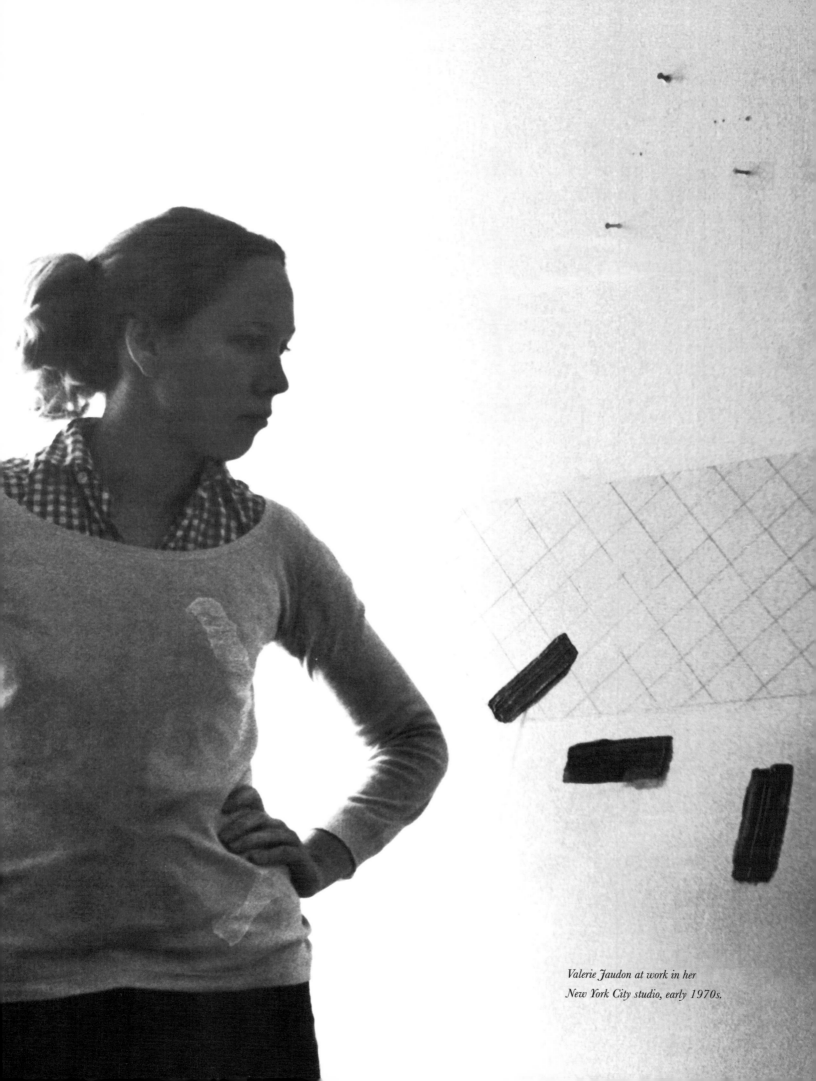

*Valerie Jaudon at work in her
New York City studio, early 1970s.*

Acknowledgments

There are numerous individuals whose diligence and determination were integral in the organization of this exhibition and production of the accompanying catalog. Most significant is Valerie Jaudon, whose unflagging interest in and generous patience with the myriad of details involved with this project went beyond expectation and allowed for a pleasurable working relationship. Without Jaudon's cooperation—and collaboration—this task would have been impossible.

The generous support of the Lila Wallace-Reader's Digest Fund enabled the timely completion of the entire project to the great satisfaction of all those involved.

In particular, special appreciation is due Anna C. Chave for her insightful essay on Jaudon's art. Susan Stroman at Sidney Janis Gallery, New York, offered ongoing assistance with numerous assorted details. Kathleen Schenck Row provided a beautiful design for this catalog. Ginger Tucker gave editorial direction to the publication, and Elizabeth McRee helped in necessary research and organization of both the exhibition and the catalog. Jane Necol's contribution to the text is also greatly appreciated.

Additionally, Linda S. Sullivan and Elizabeth Martin Brister provided direction in initial organizational and funding efforts. Richard Kalina and Timothy Hedgepeth also offered their undying encouragement and support.

At the Mississippi Museum of Art, Beth Warren Turnage, Assistant Curator/Registrar; L.C. Tucker, Chief Preparator; and Melvin Johnson, Associate Preparator provided expert assistance in their respective areas.

Finally, we are indebted to the lenders who have provided works for this exhibition: Albright-Knox Art Gallery; Richard Brown Baker; Leonard and Stephanie Bernheim; Hirshhorn Museum and Sculpture Garden, Smithsonian Institution; Paul Huston; Sidney Janis Gallery; Valerie Jaudon; Ellen and Max Palevsky; Michael and Juliet Rubenstein; Holly Solomon Gallery; Volvo North America Corporation; and a private collector.

—*René Paul Barilleaux*

8

Disorderly Order: The Art of Valerie Jaudon

by Anna C. Chave

My main interest has been to make what is popularly called decorative painting truly viable in un-equivocal abstract terms. Decoration, that is, in a good sense, in the sense that it is applied to Matisse…that's where I'd like my painting to go.

Frank Stella in a 1969 interview with William Rubin.[1]

In the mid-1970s Valerie Jaudon and others associated with the Pattern and Decoration movement mounted a drive to integrate the so-called "minor" arts of "decoration" with the "high" or "fine" arts of painting and sculpture in a bid to destabilize established cultural hierarchies and to legitimate and celebrate the decorative. On the face of it, their somewhat scrappy and, as it happened, short-lived campaign hardly reflected an unprecedented or radical initiative. That prodigy, Frank Stella—whose Protractor series [fig. 1], begun in 1967, consisted of patently decorative paintings loosely based on Islamic interlace schemes—had anticipated their move. And the ambition to make a great yet unabashedly decorative art could be traced to no less a pillar of modern art than Henri Matisse [fig. 2], as Stella himself had noted.

That Matisse should have so highly esteemed the decorative evidences the lingering effects of the nineteenth century Symbolist and Aesthetic movements, which had prized the decorative above all else, looking to it to herald a profound renovation of artistic style. Schemes to reintegrate the fine and the applied arts may also be retraced to the nineteenth century—to the mid-century British Arts and Crafts movement whose influence eventually traveled, first to the United States and then throughout Europe, where it found a kind of reincarnation in the Art Nouveau

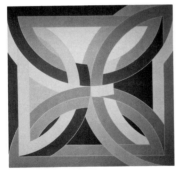

Figure 1. (below) Frank Stella, Abra Variation I, 1969, fluorescent alkyd on canvas, 120" x 119 ⁷/₈". Collection of The Museum of Modern Art, New York, New York. Gift of Philip Johnson in honor of William Rubin.

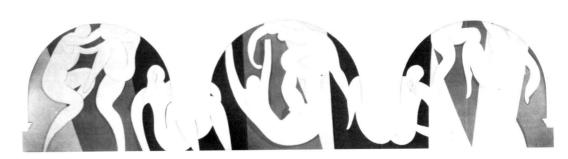

Figure 2. (right) Henri Matisse, The Dance I, 1932–1933, oil on canvas, 133 ³/₄" x 173 ³/₄" (left), 140 ¹/₈" x 198 ¹/₈" (center), 133 ³/₈" x 173" (right). Collection of Barnes Foundation, Merion Station, Pennsylvania.

[1] William S. Rubin, *Frank Stella* (New York: Museum of Modern Art, 1970), 149.

9

movement at the end of the century. John Ruskin and William Morris, whose thinking guided the Arts and Crafts movement, had looked to the Middle Ages for a model of a society that successfully integrated the aesthetic and the utilitarian. As a legacy, in part, of the movement they nurtured, a deep concern with the rapport between, or the rapprochement of, the fine and the applied arts became a vital and recurrent feature of the history of modernism throughout the first half of the twentieth century, especially. That feature emerged most prominently in the context of those more socially-oriented modern movements which imagined a perfect marriage of materialism and idealism: the productivist and constructivist schools born in revolutionary Russia and the de Stijl, Bauhaus and Purist movements conceived as would-be phoenixes from the ashes that blanketed Europe after World War I.

Time and again, sometimes under the sway of visionary architects, modern artists have aimed to narrow or to eliminate the gulf separating them from the humble artisan, to forge a productive synthesis between art and design. "As far as work is concerned, we are all craftsmen," declared the Bauhaus founder, architect Walter Gropius, for whom "the ultimate goal of all visual arts" was a utilitarian one—the achievement of "the complete building." (It must be added that Gropius finally allotted women only a restrictive and particular role in achieving that glorified building: the weaving of textiles.[2]) Over half a century later, echoes of such thinking might be heard in Jaudon's insistence that "the language of architecture, ornament and art are almost identical"[3]; in Joyce Kozloff's contention that "at its best, decoration is the coming together of painting, sculpture, architecture and the applied arts. Decoration humanizes our living and working spaces"; and in Scott Burton's ambition to develop art furniture, such as simple, beautifully formed stone chairs that ask to be viewed at once as serviceable objects and as sculpture [fig. 3]. These artists'

[2] Sigrid Wortmann Weltge, *Women's Work: Textile Art from the Bauhaus* (San Francisco: Chronicle Books, 1993), 41 and passim. "What attracted [women] to the Bauhaus in the first place was the lure of the painters—'Klee and Kandinsky'," noted Weltge, but they would be allowed to study with those masters only as a preparatory aspect of their training as weavers (ibid., 47). "Weaving I thought was too sissy. I was looking for a real job," recollected Anni Albers, of her initial lack of enthusiasm for her assigned role at the Bauhaus. In later years Albers— who became nevertheless a brilliant weaver—turned to printmaking, in no small part because "I find that when the work is made with threads, it's considered a craft: when it's on paper, it's considered art" (Martha Keller, "Women of the Bauhaus," *Heresies*, 1, no. 4 [Winter 1977-1978], 54, 55).
[3] Sam Hunter, *Valerie Jaudon* (Berlin: Amerika Haus, 1983), n.p. (exhibition catalog).

Figure 3. Scott Burton,
Pair of Two Granite Chairs,
1986, granite,
35 3/4" x 20" x 25 1/2" each.
Courtesy of Max Protetch Gallery,
New York, New York.

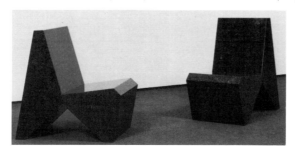

readiness to make "objects that work for a living" as the critic Carrie Rickey put it,[4] was manifest further in their willingness to develop decorative and design schemes with and for architects, a gesture of cooperation that had long since become alien to most avant-garde artists. (Jaudon's first completed public commission, a mural on the ceiling of a large lobby in a corporate building in Philadelphia designed by Mitchell/Giurgola, was executed in 1977 [figs. 4a and 4b].)

The fight the Pattern and Decoration artists burned to fight might be said to have been finished then, and the battle won—on the face of it. But in this respect, the history of modernism has been unashamedly two-faced. When Stella pronounced that he aspired to make decoration in the "good sense," he pointed indirectly to an alternate and opposite use of the term. He proceeded to add, shrewdly, that "at their best, my recent paintings are so strongly involved with pictorial problems and pictorial concerns that they're not conventionally decorative in any way."[5] To be conventionally or "merely" decorative had long been and remains an anathema to nearly all abstract artists—including, I suspect, Jaudon. Historians recognize that decorative art provided both a significant precedent for and a key tributary to the advent of modernist abstraction in the West. But "with the beginnings of practical interest in the development of abstract art," as Charles Harrison phrases it, "...the achievement of 'mere' decoration became the mark of aesthetic failure—of a failure, that's to say, to establish that promise of intellectual and emotional depth which was associated with painting as a form of art."[6]

The principal strikes against decorative art, from the perspective of most abstractionists, were its secondary and instrumental roles. Decoration's social function, its contingent status, conflicted with a vision cherished by many pioneer abstractionists of an unfettered, autonomous art form; hence "the word 'merely' came to replace 'great' as the epithet most commonly associated with the decorative."[7] Whereas Paul Gauguin, for example, could be called a "decorator" in the spirit of the highest

[4] Carrie Rickey, "Decoration, Ornament, Pattern and Utility: Four Tendencies in Search of a Movement," *Flash Art*, 90-91 (June/July 1979), 23, 22. Burton is cited in the same article as stating that the "New decoration...is leading back to the real social world of multi-class culture" (ibid., 23).

[5] Rubin, *Stella*, 149. For his part, Rubin would hedge on Stella's behalf: "The markedly decorative aspects of the interior patterning of the Protractor paintings were balanced by the strong structural concerns expressed in their field contours" (ibid., 143).

[6] Charles Harrison, Francis Frascina, Gillian Perry, *Primitivism, Cubism, Abstraction: The Early Twentieth Century* (New Haven, Conn.: Yale University Press, 1993), 204.

[7] Nancy J. Troy, "Abstract, Decoration, and Collage," *Arts*, 54, no. 10 (June 1980), 154. Troy observes that "Decorative and applied art upset the status of painting, not because they were abstract, but because they blurred the distinctions between painting and design" (ibid., 157). Troy has been a particularly important force in fleshing out the neglected history of modernist artists' involvement in decorative design and architectural projects. See her *The De Stijl Environment* (Cambridge, Ma.: M.I.T. Press, 1983).

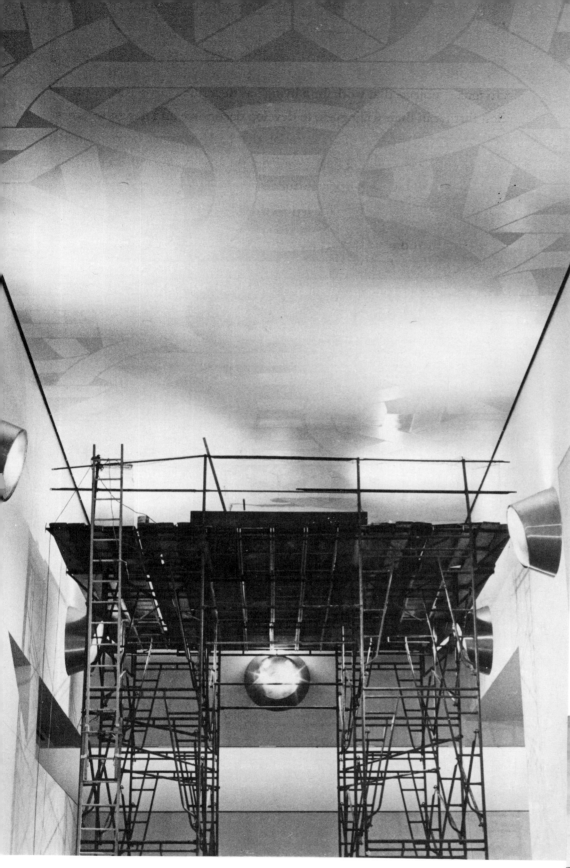

Figure 4a. (left) Valerie Jaudon, untitled ceiling mural (in progress), 1977, oil on plaster, 90' x 22'. Philadelphia INA building, Pennsylvania; Romaldo Giurgola, architect.

Figure 4b. (below) Valerie Jaudon at work on ceiling mural for the Philadelphia INA building.

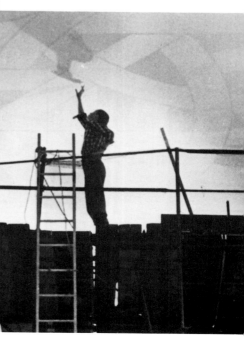

compliment by his contemporaries, the term's flattering cast was increasingly uncertain even by the time Matisse laid claim to it. Matisse specialists have long felt impelled to defend the master against his express ambition to make an art devoted, as decoration mainly is, to offering pure pleasure—art as "soothing" as "a good armchair which provides relaxation from physical fatigue."[8]

As it happens, the attempted rehabilitation by some younger scholars of Matisse's career as a decorator coincided with the advent of the Pattern and Decoration movement, which first coalesced in a series of meetings and panel discussions in New York City beginning in 1975.[9] Matisse would habitually be invoked by the partisans of Pattern and Decoration as the group's legitimate forefather, a claim that often carried a distinctly defensive tone, as does the sympathetic literature on the New Decoration movement generally. If Matisse's sometime self-identity as a decorator helped console those hoping to restore decorative modes, the fear and loathing of decoration expressed by other modernist pioneers undeniably left the larger historical impression. "The danger of ornamentation was clear," declared Wassily Kandinsky, who feared that his abstractions might be likened to or mistaken for those embellishing a mere necktie.[10] Kandinsky's mixed feelings about decoration—an ambivalence rife among modernists generally—emerged in the fact that besides making oil paintings and watercolors, he sketched dress designs and painted china and furniture, in part through his role as a Bauhaus instructor.

Notwithstanding the manifest commitment of numerous modernists to a new synthesis of fine and applied arts, then, the decorative would be mostly relegated to minor or non-art status throughout the twentieth century and carry with it an ineradicable taint. In some part, that taint was moral as well as aesthetic. If the beauty of ornament is invariably acknowledged, so too is its triviality or "superficiality…and ultimately its evil," Oleg Grabar remarks, for moral cautions are often invoked in connection with the pursuit of beauty and pleasure.[11] Those susceptible to the supposedly frivolous charms of the decorative may well be branded weak-natured, childlike or even uncivilized. "Ornament is dangerous precisely because it dazzles us and tempts the mind to submit without proper reflection," Ernst Gombrich observed. "Whatever may be true of the Far East, in the history of Western art the aesthetic ideal of restraint is inextricably interwoven with the classical tradition.

[8] Jack D. Flam, *Matisse on Art* (New York: E.P. Dutton, 1978), 38, 34.

[9] John H. Neff published "Matisse and Decoration: An Introduction" (based on his Harvard University dissertation), in *Arts*, May 1975, and Amy Goldin—who came closer than anyone to being the Pattern and Decoration group's designated theorist—published "Matisse and Decoration: The Late Cutouts," in *Art in America*, 63, no. 4 (July/August, 1975).

[10] Cited in Harrison, et al., *Primitivism, Cubism, Abstraction*, 204.

[11] Oleg Grabar, *The Mediation of Ornament* (Princeton, N.J.: Princeton University Press, 1992), 26.

The confidence with which we speak of 'barbaric splendour' betrays our deep-seated conviction that non-barbarians have other standards of excellence." Gombrich aptly noted also that "often, the rights and wrongs of ornament are discussed in terms of feminine adornment," just as, one might add, the decorative has long been discussed in terms of the feminine more generally.[12]

When the Pattern and Decoration artists banded together in the 1970s, however informally, it was in full and defiant awareness of the stigma attached to the decorative. Roughly equal numbers of female and male artists were associated with the movement which enfolded, besides Jaudon, artists as diverse as Burton, Cynthia Carlson, Richard Kalina (Jaudon's husband), Kozloff, Robert Kushner, Thomas Lanigan-Schmidt, Kim MacConnel, Miriam Schapiro, Judith Shea, Ned Smyth, Mario Yrissary and Robert Zakanitch, among others. The women occupied a distinct position in relation to the movement, however, and there was reportedly for a while some sentiment—on Schapiro's part particularly—that they ought to segregate themselves in recognition of that fact. Historically, women's creative production had generally been categorized as craft or decoration, whereas the exalted realm of the fine arts was reserved almost exclusively for men. And in the modern age in the West, women alone have been socialized to adorn themselves liberally with cosmetics, jewelry and eye-catching fashions—to transform their bodies into decorative objects. Women may see pattern "as something particularly their own," Amy Goldin noted in 1975 while enumerating some of the ramifications and perceived drawbacks of the use of pattern by artists in the West. "Pattern still seems to imply a lack of inwardness and freedom. Pattern carries the aura of craft and contrivance, although many individual aspects of pattern…have been reclaimed for art…. Pattern vitiates the impact of form and turns thought into ritual," and, as a consequence, "pattern is lethal and can kill the power of any image."[13]

Until very recently, women who endeavored to distinguish themselves as fine artists on a par with their male contemporaries were routinely told by critics, in ways both blatant and subtle, that their work did not transcend decoration. For artists such as Stella or MacConnel [fig. 5] to experiment openly with the decorative was to venture bravely away from a given locus of authority. For women (or gay, ergo putatively effeminate men, such as Burton) to make the same experiment was, in a sense, to court perversely a foregone conclusion: that their creative accomplishments simply continued conventional feminine preoccupations with domestic craft and self-adornment. Female artists generally knew to expect that no matter how skilled they

[12] Ernst Gombrich, *The Sense of Order: A Study in the Psychology of Decorative Art*, 2nd ed. (Ithaca, N.Y.: Cornell University Press, 1984), 17, 18, 61.

[13] Amy Goldin, "Patterns, Grids, and Painting," *Artforum*, 14, no. 1 (September, 1975), 50, 51.

became or how their art looked, it would likely be deemed decorative and, as such, belittled. This expectation was usually formed early on, and like legions of other women, Jaudon can recall a parade of (male) art professors who greeted her paintings with the withering remark that they looked so, well, decorative.[14] To have this blow delivered in the 1960s, when she was studying art, carried an added sting since the militantly anti-decorative art of the Minimalists came in that decade to its ascendancy.

If woman has always functioned "within" the discourse of man…it is time for her to dislocate this "within," to explode it, turn it around, and seize it; to make it hers, containing it, taking it in her own mouth, biting that tongue with her very own teeth to invent for herself a language to get inside of.

Hélène Cixous, "The Laugh of the Medusa," 1976.

The subversive language that the radical French theoretician Cixous envisioned women inventing was a language of the body. "Women must write through their bodies," she proclaimed.[15] Many feminist artists in the United States in the 1970s (though unaware of Cixous's exhortations) were bent on inventing just that. When Schapiro and Judy Chicago instituted a feminist art program at the California Institute of the Arts in 1971, they were already working toward what would be called "central core" or abstractly vaginal imagery. At the same time, they, their students and other women labored to reclaim their feminine creative inheritance: a venerable history of domestic craft production. (Special attention was paid by many to the glories of quilts which in their more abstract variations—epitomized by the

[14] " 'As far back as I can remember', says Jaudon, 'everyone called my work decorative, and they were trying to put me down by saying it' " (John Perreault, "The New Decorativeness," *Portfolio*, June/July 1979, 49). Jaudon was educated at a myriad of institutions, including the Mississippi University for Women from 1963-1965 (the choice of her mother, who stoutly resisted sending a daughter to college), the Memphis Academy of Art in 1965, the University of the Americas in Mexico City from 1966-1967, and St. Martin's School of Art in London from 1968-1969.

[15] Hélène Cixous, "The Laugh of the Medusa," rpt. in *New French Feminisms*, ed. Elaine Marks and Isabelle de Courtivron (New York: Schocken Books, 1981), 257, 256.

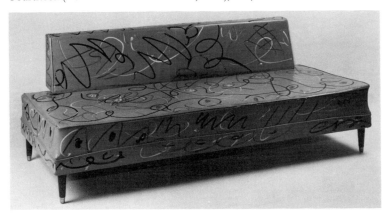

Figure 5. Kim MacConnel, Turquoise Settee, 1975, acrylic on vinyl upholstered couch, 28 1/2" x 72 1/2" x 29 1/8". Collection of The Brooklyn Museum, New York. Gift of Peter R. Stern.

handiwork of Amish women—were seen as having anticipated the advent of certain, vaunted modes of abstract painting[16]). In 1973, while praising the homage to women's crafts implicit in Schapiro's work [fig. 6], the pioneering feminist historian Linda Nochlin also noted approvingly in one painting a form "pierced at its center by a jagged hole-shape, an evocative formal wound" and, in another, a "central hole more forcefully asserted as a spatial penetration, a gap torn in the fragile tapestry of interwoven textiles surrounding it."[17]

Occasional misguided attempts have been made to link the always intently geometric art of Valerie Jaudon to this same project of painting through the body.[18] But Jaudon effectively followed the course mapped out by Cixous in a different way. "The whole idea is to change the viewer's mind," she has said[19]; and to that end she felt she needed first to solicit the viewer's respectful attention. The visual idiom she chose for her work, then, was the established modernist idiom of geometric abstraction; but she would use that idiom in a sense *against* itself, turning it around, "taking it in her own mouth," to use Cixous's words, or "polluting" it, to use her own. To command the critics' and the viewing public's recognition of her work as an authentic art form—in a way much of the craft technique-based and body-centered art of other feminists failed to do—Jaudon's strategy was to deploy the dominant, that is, masculinist "conventions, codes, values and hierarchies" while subtly, mischievously "shifting them around."[20]

By the time Jaudon began to make her art public—it debuted in New York in 1975 in a two-person show with, appropriately, the sometime artist, sometime designer Sonia Delaunay—she had openly taken Stella's admired recent work as a kind of

Figure 6. Miriam Schapiro, The First Fan, *1977, acrylic and collage on canvas, 72" x 144". Collection of Bruno Bishofberger, Zurich, Switzerland, courtesy of Steinbaum Krauss Gallery, New York, New York.*

[16] See Patricia Mainardi, "Quilts: The Great American Art," 1973, rpt. in *Feminism and Art History: Questioning the Litany,* ed. Norma Broude and Mary D. Garrard (New York: Harper and Row, 1982), 330-346.

[17] Linda Nochlin, "Miriam Schapiro: Recent Work," *Arts,* 48, no. 2 (November 1973), 39.

[18] "The eye travels every route in these labyrinthine lattices, inevitably drawn to central, angular, butterfly-shaped sexual orifices" (Constance Mallinson, "Valerie Jaudon at James Corcoran," *Images and Issues* [California], Summer 1981, 56).

[19] Interview with the author, 21 June 1994.

[20] Ibid. Jaudon understood early on that, as she later put it, "celebrating the marginal keeps the center intact" (Shirley Kaneda, "Valerie Jaudon" [interview], *Bomb,* Winter 1992, 43). But that stance marks a rift in feminist ranks—a division over "whether the attempt to valorize the neglected 'other' of high art does not instead perpetuate it as an alternative tradition, a 'woman's' [read: secondary] tradition" (Whitney Chadwick, *Women, Art, and Society* [New York: Thames and Hudson, 1990], 334). Whether or not it was politically sound, the approach of artists like Schapiro and Chicago drew no little ridicule and hostility. Alarmed, it is said, particularly by the vehemence of Schapiro's views, Donald Kuspit launched an almost apoplectic attack on the "new tyranny" imposed by "authoritarian feminism." Adjudging Pattern Painting to be a "minor, reactionary, decadent art," and the use of the central core image to be "an insignia on the order of a swastika-pattern," Kuspit excoriated such a "willful exercise of power—an attempt to achieve dominance, or at least prominence in the art world" (Donald B. Kuspit, "Betraying the Feminist Intention: The Case Against Feminist Decorative Art," *Arts,* 54, no. 3 [November 1979], 124-126).

Figure 7. Valerie Jaudon,
Yazoo City, *1975,*
oil on canvas, 72" x 72".
Collection of The Aldrich
Museum of Contemporary Art,
Ridgefield, Connecticut.

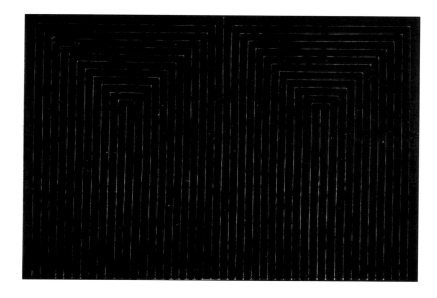

Figure 8. Frank Stella,
The Marriage of Reason
and Squalor, II, *1959, enamel
on canvas, 90 ³/₄" x 132 ³/₄".
Collection of The Museum of
Modern Art, New York, New York.
Larry Aldrich Foundation Fund.*

springboard. She began, as he had, with sized, unprimed canvas, covered with hand rendered (not squeegeed or taped) monochrome stripes of uniform width, demarcated by thin canals of reserved, unpainted canvas, and organized in a symmetrical manner (quadrilateral symmetry in the case of her early work, bilateral symmetry in the case of Stella's). *Yazoo City* of 1975 [fig. 7] answers to this description, no less than does Stella's *The Marriage of Reason and Squalor, II* [fig. 8], though the curves and the schematic interlacing that distinguish *Yazoo City* from Stella's austere "pinstripe" painting attest to Jaudon's close acquaintance with the blatantly decorative pictures of the later Protractor series [see fig. 1]. (On another note, the particular, six-foot square format of *Yazoo City*, a format Jaudon used repeatedly at first, would implicitly link her with two other admired, contemporary geometric abstractionists, Ad Reinhardt and Agnes Martin.)

The title of Jaudon's painting, like the titles of her early work generally, refers to a town in her native Mississippi, whereas Stella's Protractor pictures were mostly named for ancient circular cities in Asia Minor, for Islamic cities, and for gateways to the "round city" of Baghdad.[21] Jaudon shared with Stella not only his abiding fascination with architecture and the lexicon of form it encompasses, but also his admiration for the great decorative traditions of Islam and of Celtic illumination, in their genius for inventive, intricate, interlace design. What Jaudon looked to in the Islamic (and in the Western medieval) traditions that did *not* notably matter to Stella was its broad social reach and appeal, its identity at once as a highly cultivated or elite and a popular or vernacular art with rich qualities accessible to all.[22]

[21] Rubin, *Stella*, 129.

[22] On a journey to southern Spain (with a stop at The Alhambra) and to Morocco in the summer of 1969, Jaudon recalls feeling deeply impressed by the "pervasiveness of Islamic art"; by the "unifying" way it functioned to "connect a whole society"; by its "importance to people generally." Her stops at medieval cathedrals and towns in Europe on those same, extended, college-student travels adduced related perceptions (Interview, 21 June 1994).

Figure 9. Valerie Jaudon,
Mound Bayou, *1978,*
oil and metallic pigment
on canvas, 72" x 72".
Private collection.

In Islamic art "pattern is not a repository for the psychodramas and idealisms that preoccupy modernism; it is a socializing extension of presence to all appropriate surfaces," Janet Kardon observed.[23] Like many of the (Pop and Minimalist) artists who emerged in the 1960s, Jaudon disdained the mythology of the artist as a preternaturally sensitive and inspired individual, heroic in his fidelity to a uniquely special and original vision—a type exemplified by the Abstract Expressionist artist.[24] Her experiences of medieval and Islamic architecture and design on trips through Europe and North Africa in 1968 and 1969 recommended to Jaudon an alternate model for the artist. She became convinced that "art should not be merely personal, an expression of self" or "just this free thing that people do," but that it should have a "social function," represent a purposeful "communication."[25] "What seems important today," she has said, "is our social and public nature, our shared survival. In the fifties [by contrast] the emphasis was on the nature of the individual, individuality in the face of the institutions and powerful conventions."[26]

The way in which *Yazoo City* and subsequent, more fully realized efforts like the stunning *Mound Bayou* [fig. 9] separated themselves from Stella's art was in part by their very deference to his example, their refusal to claim any profound originality; in part by their more unabashed decorativeness, hence their potentially crowd-pleasing aspect; and, as a factor of that, in part by their excess, as Jaudon's patterns busily mirror and multiply themselves to the point of "too much repetition, too many curves"[27]—and too lush a surface in the case of the latter, glittering gold picture. Endless, apparently mindless repetition may connote stereotypical women's work such as knitting and weaving. Here again, Jaudon pursued a scheme akin to that outlined by Cixous, seizing an aspect of the demeaned position accorded her " 'within' the discourse of man" and working to "dislocate" it, in this case by sharply magnifying or flaunting it. Jaudon's forerunner in this strategy was the sculptor Eva Hesse who had recognized that excessive repetition could send a subtly disturbing message—that of something or someone (a woman) moving beyond established

[23] Janet Kardon, *The Decorative Impulse* (Philadelphia: Institute of Contemporary Art, 1979), 4. Jaudon has mentioned admiring this text.

[24] Jaudon confessed in an interview in 1992 that she did not really appreciate Abstract Expressionism (Kaneda, "Valerie Jaudon," 42). A decade before, she took a more conciliatory position: "I loved the work of Pollock, de Kooning and Newman. But their rhetoric and rationale was for me unbelievable, and unacceptable, both as a woman and as an artist" (Hunter, *Valerie Jaudon*, n.p.).

[25] Interview with the author, 15 June 1994.

[26] Demetrio Paparoni, "Valerie Jaudon" (interview), *Tema Celeste*, 36 (Summer 1992), 72.

[27] Interview with the author, 15 February 1994. I focus in this essay principally on the body of work from Jaudon's first decade of professional activity, 1975-1985. Not having the space to treat her entire career to date, I preferred to focus on the genesis of her art and, by the same token, on work connected to a specially rich historical context.

bounds, outside rational control. "Repetition exaggerates…," Hesse observed. "It's not just an esthetic choice. If something is absurd, it's much more exaggerated, much more absurd if it's repeated."[28]

Jaudon began by emulating the art of Stella, which enjoyed the full sanction of eminent critics, historians and art institutions. But in parroting his idiom in such an exaggerated way, she pushed it further than Stella or his supporters would ever have wished it to go—toward decoration not only in the "good sense" identified with Matisse. So plenteous are the reflexively repeated motifs of *Yazoo City* and *Mound Bayou* that their pictorial structures beg comparison with such humble, yet often technically and visually complex crafts as basketry, weaving and wallpaper or fabric design. Though she embarked from established premises in her use of geometry and generally complied with the *sine qua non* of successful abstract painting as decreed by Greenberg and his acolytes (namely by emphasizing the canvas's flatness and the formal exigencies supposedly dictated by its framing edge), Jaudon contrived to land on grounds quite foreign to that carefully staked and protected terrain. Observant critics were impelled to describe her art in notably incommensurate terms: as "commanding," even "imperious," and "emanating confidence," on the one hand, and evincing "weaving…jeweled luminosity…[and] the complexities of filigree" on the other, for instance.[29]

In an interview with Cindy Nemser, Eva Hesse described how, as she worked on a new sculpture, it

left the ugly zone and went to the beauty zone. And it became for me—I don't even want to use the word in any interview of mine—decorative. That word or the way I use it or feel about it is the only art sin.[30]

The tragic early death of Eva Hesse from a brain tumor in 1970 had a substantial effect on Valerie Jaudon, as it did on many artists. Female artists, in particular, generally admired Hesse for having succeeded in New York's male-dominated art community, not by denying her feminine identity (as some others had done), but by insisting upon it—if in her own sly ways. Hesse took the boastfully virile language

[28] Cited in Lucy R. Lippard, *From the Center: Feminist Essays on Women's Art* (New York: E.P. Dutton, 1976), 65. Lippard identified repetitiousness as a characteristic, early strategy of feminist art practice (ibid., 86, 194, 240).
[29] Carrie Rickey, "Reviews," *Artforum*, 17, no. 5 (November 1979), 62. Another example is Hilton Kramer, who found that Jaudon made an "emphatic impression" by her "rigorous, repetitious but airy and elegant design…painting that looks 'tough' but decorative at the same time" (Kramer, "Seven Young Americans," *New York Times*, 18 April 1980, c21).
[30] Cindy Nemser, *Art Talk: Conversations with Twelve Women Artists* (New York: Charles Scribner's Sons, 1975), 217.

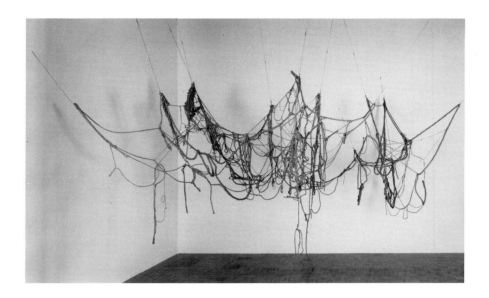

of Minimalism "into her own mouth," making it sound strangely altered. She managed to use the technocratic and masculinist visual idiom of Minimalism[31] against itself, in effect, in a move to restate and reclaim certain contemptuous stereotypes of femininity: that of Woman as Arachne, the treacherous weaver of webs— evoked by the erratic, macramé-like net formed by an untitled rope sculpture of 1970 [fig. 10]—possessed of a no less ensnaring "snatch"—evoked by the hairy-looking (Pandora's) boxes she called *Accession* [fig. 11].[32] This strategy could be compared, however loosely, with the practice among some marginalized populations, such as young African-Americans or gays, of seizing terms such as "nigger" or "queer," used to denigrate them and diminishing their toxic sting by inverting them into terms of, however ironic, endearment or affirmation.

Hesse obliquely, abstractly explored the feminine in her sculpture; but she knew better than to let a critic like Nemser pigeonhole her art in feminist terms, which would have redounded to her detriment, by marginalizing her art. Her horror at the prospect of even uttering the word "decorative" symptomatizes her equal determination to avoid being identified with those areas of artistic practice deemed feminine, thus minor. In making as long a run as possible around the terrain of the decorative, Hesse ended up delving deeply and fruitfully into the realm of the grotesque. Resentful, nonetheless, that Hesse's gender had functioned to curb her esthetic options, Jaudon determined to pursue a different tack.

The germ of Jaudon's decision to insist emphatically on the decorativeness of her art had to do with Hesse's predicament: "She had forbidden the word 'decorative' be used with her work," Jaudon noted, "and I imagine that was why she was using

Figure 10. (above) Eva Hesse, Untitled (Rope Piece), *1970, latex over rope, string and wire, two strands: dimensions variable. Collection of Whitney Museum of American Art, New York, New York. Purchase, with funds from Eli and Edythe L. Broad, the Mrs. Percy Uris Purchase Fund and the Painting and Sculpture Committee.*

Figure 11. (below) Eva Hesse, Accession V, *1967, steel and rubber, 10" x 10" x 10". Collection of Wadsworth Atheneum, Hartford, Connecticut. The LeWitt Collection.*

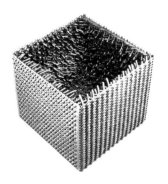

[31] On this subject, see Anna C. Chave, "Minimalism and the Rhetoric of Power," *Arts,* January 1990, 44-63.

[32] See Anna C. Chave, "Eva Hesse: 'A Girl Being a Sculpture'," in *Eva Hesse: A Retrospective*, ed. Helen A. Cooper (New Haven, Conn.: Yale University Art Gallery and Yale University Press, 1992), 99-117.

all this disgusting material, so that no one could call her work decorative.... I saw her...having to deny something so heavily and I didn't want to do that. Then I thought, well, let's just admit it; don't be afraid of the pretty, or anything else for that matter. I'm going to make the most beautiful painting that I can possibly make."[33] Even tempered, yet possessed of an obstinate contrariety (a character trait of many a successful feminist), Jaudon resolved that if the decorative was what she was not supposed to do, it was what she would do with a vengeance; to her the decorative signified "this place I'm trying to go to that everybody fears and hates."[34] She approached with a parallel attitude the tidings widely circulating, by the mid-1970s, of the death of painting.[35] If such areas were taboo, it had to be because of their very (be it latent or manifest) powerfulness. After all, painting was historically the preeminent art in the West; it was practically "a sacred site.... It *represents* art."[36]

The prejudice against the decorative has a long history and is based on hierarchies: fine arts above decorative arts, Western art above non-Western, men's art above women's.

Jaudon and Kozloff, *Heresies,* 1977-1978.[37]

Never much of a polemicist on her own behalf, and indeed leery of the felt need of some artists to append long, explanatory critical texts to their work—texts that not incidentally of course fulfill a function of self-promotion—Jaudon nonetheless took one opportunity to publish a kind of manifesto. Though no doubt self-serving in its own way, "Art Hysterical Notions of Progress and Culture," which she composed in tandem with Kozloff, held critical ramifications extending well beyond a defense of the authors' shared aim of reclaiming the decorative to an attack on the misogynist, ethnocentric and racist attitudes ingrained in certain accepted modes of art historical thinking. The Pattern Painters were "part of the sixties generation, an intensely moral generation. They demonstrated for civil rights, against the war in Vietnam and for ecological awareness," Jaudon's first dealer Holly Solomon proclaimed.[38] If

[33] Kaneda, "Valerie Jaudon," 42. Elsewhere, Jaudon has credited Kozloff for encouraging her to wear the widely despised mantle of the decorative: "We actually hated the word," she recalled, "but then Joyce [Kozloff] said, 'God we might as well admit it and say it' " (Hunter, *Valerie Jaudon*, n.p.).

[34] Interview, 15 June 1994.

[35] For example, *Artforum* magazine asked a sampling of painters to respond to the following statement, "It appears that painting has ceased to be the dominant artistic medium at the moment...those understood to be making 'the next inevitable step' now work with any material but paint" ("Painters Reply," *Artforum*, 14, no. 1 [September 1975], 26).

[36] Interview, 21 June 1994.

[37] Valerie Jaudon and Joyce Kozloff, "Art Hysterical Notions of Progress and Culture," *Heresies*, 1, no. 4 (Winter 1977-1978), 38-42.

[38] Nancy N. Rice, "Pattern and Decoration," *The New Art Examiner* [Chicago], March 1980, 2.

such a heightened political consciousness was not conspicuous in the art in question, it was unmistakably and impressively apparent in the issue of *Heresies*, a collectively run feminist journal of art and politics, that Jaudon and Kozloff helped edit and to which they contributed.

An initial impulse behind the fourth issue of *Heresies*, devoted to "Women's Traditional Arts: The Politics of Aesthetics," had been to honor past and present women's craft production viewed globally. The fruits of an open call for, and active solicitation of, manuscripts from feminist scholars and artists soon persuaded the editorial collective to expand their aims, however, by evincing a more complex view of craft as at once a vital outlet for women and an instrument in their repression.[39] The magazine the editors assembled encompassed a range of texts—from the anecdotal to the scholarly and theoretical—many of which represent pioneering and moving personal and intellectual investigations. The issue featured articles by among others, Howardena Pindell on "Afro-Carolinian 'Gullah' Baskets," a text incorporating a harrowing patchwork of slave narratives; Bella Lieberman on "Lacemakers of Western Europe," reporting that "many lacemakers went blind by the time they were thirty" due to their labors; and Elizabeth Sacre, on the "New Zealand Maori," revealing that the first thumb joint of female Maori babies was "bent outwards in anticipation of certain tasks" they were to perform, namely weaving. Other contributions included Hayden Herrara's "Portrait of Frido Kahlo as a Tehuana," Martha Keller's "Women of the Bauhaus," Judith Friedlander's "The Aesthetics of Oppression: Traditional Arts of Women in Mexico" and Teresa de Lauretis's "The Left Hand of History." "No formal criteria for 'feminine art' can be definitively laid down," argued de Lauretis in her essay. "We need a theory of culture with women as subjects—not commodities but social beings producing and reproducing cultural products, transmitting and transforming cultural values. In this sense, and so that we can take possession of our cultural (re)production, I think we should assert that women's work is never done."[40]

Jaudon and Kozloff's piece, following the proven tactic of hanging malefactors by their own ropes, consisted of a compilation of quotations from various scholars, critics and artists, most of whom have occupied authoritative positions in the hierarchies of modernism, punctuated by brief commentaries underscoring the bias-laden subtexts of the cited texts. As the above-cited passage from their analysis shows, they were

[39] Besides Jaudon and Kozloff, the editorial group included Martha Edelheit, Melissa Meyer, Rickey, Elizabeth Sacre, Schapiro, Elizabeth Weatherford and Sally Webster. (The design group for the issue included among others, Kozloff, Barbara Kruger and Schapiro.) Like the issue in question, many of the early issues of *Heresies* were highly prescient for their day in broaching complicated, at times atypical feminist issues and treating them with a laudably balanced combination of cerebration and passion.

[40] Teresa de Lauretis, "The Left Hand of History," *Heresies*, 1, no. 4 (Winter 1977-1978), 26. (De Lauretis's article centered on the women in the life of the Italian communist theorist Antonio Gramsci.)

concerned with more than misogynist biases. Countering Schapiro's view of craft and decoration as undervalued "work by women almost exclusively,"[41] Jaudon and Kozloff were no less troubled by the ethnocentric and racist implications of the bias against craft traditions, which they well knew to be, from a global perspective, at least as much the province of (generally non-Western) men as of women. They cited as symptomatic of Westerners' contempt for other cultures, for instance, the architect Adolf Loos's polemic "Ornament and Crime" of 1908, which pronounced that "No ornament can any longer be made today by anyone who lives on our cultural level. I can tolerate the ornaments of the Kaffir, the Persian, the Slovak peasant woman, my shoemaker's ornaments, for they all have no other way of attaining the high points of their existence. We have art, which has taken the place of ornament."[42]

Jaudon and Kozloff understood that the Western bias against the decorative entailed a gargantuan and disgraceful blindspot toward the accomplishments of virtually all other cultures of the world—cultures not in thrall, as Westerners generally have been, to mimetic and naturalistic norms or (Western) narrative modes. (Unfortunately, the insidious cultural chauvinism to which they pointed remains, if somewhat less blatant, nonetheless rife in the art historical profession today, as the Islamicist Grabar only recently complained.[43]) In their art, however, Jaudon and Kozloff responded differently to this realization. Kozloff made compensatory acts of homage by composing eclectic pastiches of diverse, non-Western visual idioms, and by working not only in fine art media but, as time went by, in craft media such as ceramic tile [fig. 12]. Jaudon managed to avoid the accusation that Kozloff's appropriative practices drew of an, however inadvertent, act of cultural

[41] A view she spelled out most recently in Corinne Robins, *The Pluralist Era: American Art, 1968-1981* (New York: Harper and Row, 1984), 137-138, and in her convocation address to the College Art Association convention in New York City in February 1994.

[42] Jaudon and Kozloff, "Art Hysterical Notions," 40. Concluded Loos, "*The evolution of culture is synonymous with the removal of ornament from utilitarian objects*" (ibid. [emphasis in original]). Loos had been deeply influenced by the Arts and Crafts movement; and Ruskin had taken a comparable stand: "The fancy and delicacy of eye in interweaving lines and arranging colours—mere line and colour, observe, without natural form—seems to be somehow an inheritance of ignorance and cruelty…. Get yourself to be gentle and civilized…and somehow or other you will find that you will not be able to make such pretty shawls as before" (Gombrich, *Sense of Order*, 46; Gombrich also discusses Loos's views [ibid., 60-61]).

[43] With Gombrich's erudite *The Sense of Order*, Grabar's *The Mediation of Ornament* is perhaps the definitive, contemporary text on the decorative. Grabar distinguishes his own approach as follows: "to Gombrich…what is truly important about art…is the nonornamental, that grand and grandiose recreation of the natural world that forms, at least within a mainstream art historical tradition, the major achievement of Western painting. It is at that level that I part company with Gombrich's positions…in part by rejecting the European-centered criticism of a vision of art based so exclusively on Western representations"; and "It is…certainly a sign that practically nothing has been written about the complex relations between Western art and the art of the rest of the world in the twentieth century…it is difficult not to understand the anger of so many artists and interpreters of the arts in other lands who feel excluded from a common adventure controlled by Western media" (ibid., 40, 241).

imperialism,[44] by declining to quote directly from other traditions, yet mining them (along with elements of the Gothic style) for alternative paradigms of artistic practices and synthesizing some of the prodigious lessons in design they offered.

The writings and the support of a maverick historian and partisan of decoration, the critic Amy Goldin, encouraged Jaudon and numerous other artists of the Pattern and Decoration group, who were looking with equal eagerness to cultures outside the West.[45] Informed by the spirit of valorization that Goldin brought to her intellectual encounter with Islamic culture, the operation Jaudon performed must be distinguished from the primitivizing and exoticizing operations deployed by early modernists such as Gauguin and Matisse. In a postcolonial age, the tacit presumption of Western superiority had to a degree eroded, as had the bias against cultures that value tradition as much as or more than invention or, what is conceived as progress. One of the distinctive characteristics of postmodern artistic practice is pastiche, as Fredric Jameson astutely observes; and while pastiche is imitation, "it is a neutral practice of such mimicry, without any of parody's ulterior motives, amputated of the satiric impulse…and of any conviction that alongside the abnormal tongue you have momentarily borrowed, some healthy linguistic normality still exists."[46] Moreover, Andreas Huyssen comments on the postmodern intrigue with premodern cultures, that it may well "express some genuine and legitimate dissatisfaction with modernity and the unquestioned belief in the perpetual modernization of art."[47]

[44] Several critics were moved to defend Kozloff against these charges, which were rarely made in print. (See Rickey, "Decoration, Ornament, Pattern and Utility," 20; Kay Larson, "Imperialism with a Grain of Salt," *Village Voice*, 17 September 1979, 79; and Jeff Perrone, "New York," *Artforum*, 18, no. 3 [November 1979], 79).

[45] Goldin taught courses on aesthetic and art criticism highlighting the importance of the decorative and, especially, of the Islamic tradition, at the University of California, San Diego in 1970-1971 (overlapping on the faculty with Schapiro); her teaching strongly affected two students there, Kushner and MacConnel. Goldin's published writings on the subject of the decorative, from 1975-1978 (after which she died an untimely death) are cited throughout the present text. See Robins, *Pluralist Era*, 131-133.

[46] Fredric Jameson, "Postmodernism, or The Cultural Logic of Late Capitalism," *New Left Review*, 146 (July/August 1984), 65.

[47] Andreas Huyssen, "Mapping the Postmodern," *After the Great Divide: Modernism, Mass Culture, Postmodernism* (Bloomington: Indiana University Press, 1986), 185. Huyssen importantly notes, further, that "There is a growing awareness that other cultures, non-European, non-Western cultures must be met by means other than conquest or domination…and that the erotic and aesthetic fascination with 'the Orient' and 'the primitive'—so prominent in Western culture, including modernism—is deeply problematic" (ibid., 220). Helping substantially to persuade Western intellectuals of their prejudiced vision of the so-called Orient was the Palestinian-born scholar Edward Said's Foucaultian study, *Orientalism* (New York: Random House/Pantheon, 1978).

Figure 12. Joyce Kozloff, Study for Harvard Square Subway Mural, 1979, watercolor on paper, 9" x 81". Courtesy of the artist.

Numerous artists in the Pattern and Decoration group seem not to have felt strongly connected to their own cultural roots in the first place, nor duly indoctrinated in the putatively unmatched wonders of the Western European visual tradition. Jaudon hailed from a small town in the immutably rural deep South—Greenville, Mississippi; from a state with, then, but a few museums. Though an extraordinary, circuit-riding art teacher in the local elementary school, Maxine Holcomb, succeeded in firing her interest in art, Jaudon knew little of its history and did not enter an art museum until she first arrived in New York at the age of nineteen. As awestruck as she was on that occasion, by the treasures of The Metropolitan Museum of Art, she remembers being naively no less impressed by, say, the exceptionally elaborate elevators at Lord and Taylor department store.[48]

Some other key figures in the Pattern and Decoration movement were Californians, or had spent formative years there, and the notoriously deracinated, increasingly multi-ethnic inhabitants of California were likewise (until recently) lacking in major museums of Western art.[49] Many Californians were also, in certain ways, nearly as oriented toward Asian culture, just over the Pacific, as toward that of Europe, across the remote Atlantic; and there was the factor too of the Islamic or Moorish cultural traces lingering in the state's Spanish heritage. (Among numerous European and a few American critics the perception would take hold that Pattern and Decoration was a Californian movement, though its exhibition history and the majority of its social and intellectual history has been New York based.) Further, not incidentally helping to fix the attention of the Pattern and Decoration artists to the Asian continent and to the Near East generally (if not to their visual heritages), were major political events—hence persistently prominent news stories—of the period, namely the Vietnam war, events in China and the major shifts in Sino-Soviet and Sino-American relations, and the formation of OPEC.[50]

[48] Interview, 15 June 1994.

[49] Goldin, Kozloff, Kushner, MacConnel, Schapiro and Zakanitch were based in California during, at the least, significant interludes of their lives. With a knack for landing herself in hotspots—she sojourned in Paris for a time in 1968—Jaudon spent the summer of 1967 in Berkeley, and a subsequent, less memorable period in Santa Cruz. On the subject of the high cultural void in California (one since markedly reduced), see the amusing "L.A. Demystified! Art and Life in the Eternal Present," rpt. in *The Hydrogen Jukebox: Selected Writings of Peter Schjeldahl, 1978-1990*, ed. Malin Wilson (Berkeley: University of California Press, 1991), 80-90.

[50] Critics concerned with Pattern and Decoration generally ignored the larger political context, though Perreault did once remark, "It is ironic that just at the time when the public has been conditioned by conscious and unconscious racism in the media to hate anything Islamic—*they*...are causing runaway inflation—our artists have come up with art that owes a great deal to Near Eastern culture" (John Perreault, "Mideast Pipeline," *Soho Weekly News*, 14 November 1981, 34).

[51] Clement Greenberg, "On the Role of Nature in Modernist Painting," 1949, rpt. in *Art and Culture* (Boston: Beacon Press, 1961), 174.

Only when it becomes mere decoration does abstract art proceed in a void and really turn into "dehumanized" art.

Clement Greenberg, "On the Role of Nature in Modernist Painting," 1949.[51]

At the time Jaudon made the New York art community her home, in the fall of 1969, she saw at once that a single figure functioned as a kingpin and kingmaker among critics, and that the venerable "Clem," active in his profession since the late 1930s, still held what amounted to a lock on the United States' art critical discourse. Jaudon resented Greenberg's reign, perceiving his basically formalist critical system as, in effect, a system of exclusion—one that even reminded her, by its righteousness and absoluteness (not to mention its irrational aspect) of the system of white suprematism that structured and permeated social relations in her native Mississippi and that had driven her from the South.[52] From the first, Jaudon has said, her work has been "a response to limits," and she became determined to help break the "stronghold of [Greenbergian] modernism."[53]

Although Jaudon was not deluded in her high estimation of Greenberg's power, his lock had begun to be picked by the time she settled in New York. By its blank assertion of the materiality of its pared-down objects, the Minimalist movement that emerged in the 1960s represented at once the ultimate fulfillment and the exceeding of Greenberg's dictum that the very means of art were its meaning.[54] As for Pop art, which came to the fore in the same period, its wallowing in the vulgar and the vernacular amounted to a resounding slap in the face to all that Greenberg prized.[55] By the 1970s then, the perception was afoot that Greenberg's circumscribed notion of a

[52] Interview, 21 June 1994. Jaudon grew up feeling isolated by her unpopular views on racial relations, views informed in part by television news stories on the Civil Rights Movement. So horrified was Jaudon's mother by her daughter's liberal, ergo "communist" views that she made regular threats to have her committed—threats Jaudon understood to be, if not altogether serious, not totally without foundation, since her mother's duties as a town clerk included the signing of papers committing the insane and others troublesome to their families to the regional mental institution. A private meeting with a S.N.C.C. (Student Nonviolent Coordinating Committee) operative, traveling through Greenville in mufti, reassured her that she could look forward to living some day among others of like mind.

[53] Kaneda, "Valerie Jaudon," 42; Susan Gill, "Valerie Jaudon," *Art News*, 84, no. 7 (September 1985), 137.

[54] "Minimal works are readable as art, as almost anything is today, including a door, a table, or a blank sheet of paper," Greenberg complained in 1967; "...it would seem that a kind of art nearer the condition of non-art could not be envisaged or ideated at this moment. That, precisely is the trouble" (Greenberg, "Recentness of Sculpture," 1967, rpt. in *Minimal Art: A Critical Anthology*, ed. Gregory Battcock [New York: E.P. Dutton, 1968], 183).

[55] That Minimalism "consummates [modernist practice], completes and breaks with it at once" is convincingly argued in Hal Foster, "The Crux of Minimalism," in *Individuals: A Selected History of Contemporary Art, 1945-1986*, Museum of Contemporary Art, Los Angeles, exhibition catalog (New York: Abbeville, 1986), 178.

fundamentally self-referential, high modernist art—a vision so selective it debarred such vitally influential nonconformists as Marcel Duchamp and Andy Warhol—represented a one-way, deadend street. In that decade, "the historical limits of modernism, modernity, and modernization came into sharp focus," together with a "growing sense that we are not bound to *complete* the project of modernity…the sense that art is not exclusively pursuing some telos of abstraction, non-representation, and sublimity."[56]

Jaudon has a sense of having matured as an artist virtually at the cusp between modernity and postmodernity, and a sense of her work—which at first held Minimalism in an ambivalent embrace—as having contributed to the unfolding of postmodern visual culture.[57] Numerous of the concepts identified with postmodernity first emerged in architectural theory, and Jaudon's introduction to its premises came through her relationship with Romaldo Giurgola, whose architectural firm shared some key elements of the vision of fellow Philadelphia-based architect Robert Venturi. In the summer of 1974, while housesitting for the Giurgolas, Jaudon read voraciously in his professional library, including Venturi's germinal book (first published in 1966), *Complexity and Contradiction in Architecture*. In that text Venturi famously inverted modernist architecture's unofficial rallying cry "less is more" to read "less is a bore." And Jaudon responded to his notion that an inclusive "both/and" approach for architects had more to recommend it than the "either/or" exclusivity of the modernists, whose "cult of the minimum" had put architecture at risk of isolation "from the experience of life and the needs of society." Venturi reasoned that just as our lives, times and surroundings are rife with contradictions and complexities, so should our new architecture be. He advocated a more socially aware, contextually sensitive architecture, one marked by the selective retrieval of those conventions still cherished and, however crudely, deployed by a mass public that had never bowed to modernism's austere regime. The architect should "use convention unconventionally," Venturi directed, which included the recuperation of that ingratiating and communicative element of architecture: ornamentation or applied decoration, the element so loathed by canonical modernists.[58]

Once Venturi expressed his discontent with the proverbially sterile glass and metal boxes of high modernist architecture, other critics began voicing their aversion to the metal boxes and regulation grids of the Minimalists, targeting such artists as Donald

[56] Huyssen, "Mapping the Postmodern," 217 (emphasis in original). Adds Huyssen, "Rather than being bound to a one-way history of modernism which interprets it as a logical unfolding toward some imaginary goal, and which thus is based on a whole series of exclusions, we are beginning to explore its contradictions and contingencies, its tensions and internal resistances to its own 'forward' movement" (ibid.).

[57] Interview, 21 June 1994.

[58] Robert Venturi, *Complexity and Contradiction in Architecture*, 2nd ed. (New York: Museum of Modern Art, 1977), 17, 16, 40, 42.

Judd [fig. 13] and Carl Andre. As muttering grew over the diet of "sensual starvation" imposed by the Minimalists, partisans of Pattern and Decoration hastened to interject that that movement might best fill the Minimalist void. "We need more than silent cubes, blank canvases and gleaming white walls…interiors that are more like empty meat lockers than rooms to live in," exclaimed John Perreault. "Pattern Painting and Decorative Art may be coming to the rescue."[59] The symbiosis of the New Decoration in art and architecture is readily illustrated by Jaudon's collaboration with the Mitchell/Giurgola office on a series of five projects between 1975 and 1977—as well as by a number of her (and others') additional architectural commissions.[60]

Jaudon's positive experiences with Mitchell/Giurgola inspired her to use more architectural elements in her paintings, such as the Gothic and Romanesque-looking arches and gablelike formations found in *Pantherburn* (1979) and in her print, *Untitled* (1981) [figs. 14, 17]; to work on a larger, more architectural scale; and to experiment with more perspectival and more penetrable pictorial spaces. A shift in 1979 to a (now sometimes rectangular) format involving bilateral symmetry and to pictorial structures with a clearer top and bottom is also apropos here, as is the move to a distinctly impastoed stucco-like brushstroke—a kind of markmaking at once handmade and impersonal looking. Critics have not always paid close attention to the slow, steady, sometimes subtle metamorphoses Jaudon's art has undergone; but from 1979 through 1984, as her engagement with architecture intensified, her imagery evinced less small-scale decorative crafts—like Celtic illumination, or the basketry, filigree and knotting often mentioned by critics—and more the traditions of architectural design

[59] John Perreault, "A Room with a Coup," *Soho Weekly News*, 13 September 1979, 47. The chief critic for the erstwhile *Soho Weekly News*, Perreault was Pattern and Decoration's most consistent and ardent supporter, and he played a germinal role in the movement by organizing its first extensive group exhibition, at the New York City alternative space, P.S. 1 in 1977. The first show on the subject was "Ten Approaches to the Decorative," at the Alessandra Gallery in New York in September 1976. First to identify Pattern Painting as an emerging phenomenon was Amy Goldin, "The 'New' Whitney Biennial: Pattern Emerging?," *Art in America*, 63, no. 3 (June/July 1975), 72-73.

[60] The relation is presented also, in a broader scope, in Robert Jensen and Patricia Conway, *Ornamentalism: The New Decorativeness in Architecture and Design* (New York: Clarkson N. Potter, 1982). Jaudon's completed projects for Mitchell/Giurgola include the lobby ceiling mural mentioned above and a collaboration on the main entrance plaza, inner courtyard and pool in the east plaza entrance of the historic Wainwright building, Saint Louis, the renovation of which was finished by Mitchell/Giurgola in 1981.

Figure 13. Donald Judd, Untitled, *1965, aluminum, 8 1/4" x 253" x 8 1/4". Collection of Whitney Museum of American Art, New York, New York. Purchase, with funds from the Howard and Jean Lipman Foundation, Inc.*

Figure 14. Valerie Jaudon,
Pantherburn, *1979, oil and*
metallic pigment on canvas,
96" x 72". Collection of the artist.

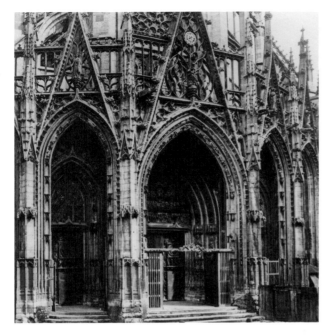
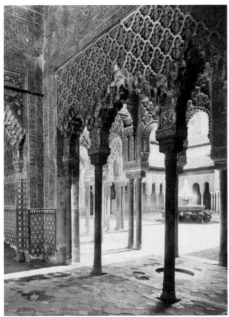

Figure 15. (left) St. Maclou, Rouen, France, c. 1500-1514.

Figure 16. (right) The Alhambra, Granada, Spain, 1354-1391.

and ornamentation, such as the flamboyant phase of the Gothic style [fig. 15], the elaborate structural articulation and decorative programs of Islamic monuments like The Alhambra [fig. 16] or, more narrowly, the intricate, eclectic, ornamental schemes of the architect Louis Sullivan.

In all events, the external references Jaudon's art invoked and invokes derive from what have conventionally been viewed as non-art realms, namely the functional domains of craft, decoration and architecture. But even as she ventured beyond the borders of high art, Jaudon proved more restrained than others in the Pattern and Decoration group. What characterized the group generally—and here critics routinely isolated Jaudon as the odd-woman-out—was an exuberant embrace of popular or commercial culture or, at least, of far humbler crafts than appealed to Jaudon. (Kozloff and Burton were also in their own ways misfits on this score.) Fortified in their scavenging through the fields of mass culture by the prior investigations of the Pop artists and abetted by the wealth of geegaws available in certain southern California and New York City neighborhoods (such as Canal Street and Chinatown, cheek by jowl with the downtown art district of Soho) artists like Carlson [fig. 18], MacConnel and Smyth turned, respectively, to loud wallpaper and cake decoration, garish or cheesy fabric design and the ersatz palm trees and faux-exoticisms of California's vernacular, built culture. Kushner [fig. 19], as another example, wryly said of himself, "young Robert was influenced by the Burpee Seed Catalogue, Paul Poiret, Matisse, Busby Berkely, and the Watts Towers."[61] Aiming to play havoc with the elitism and Puritanism that have tended to mark the reception of modernist art,

[61] Rickey, "Decoration, Ornament, Pattern and Utility," 23.

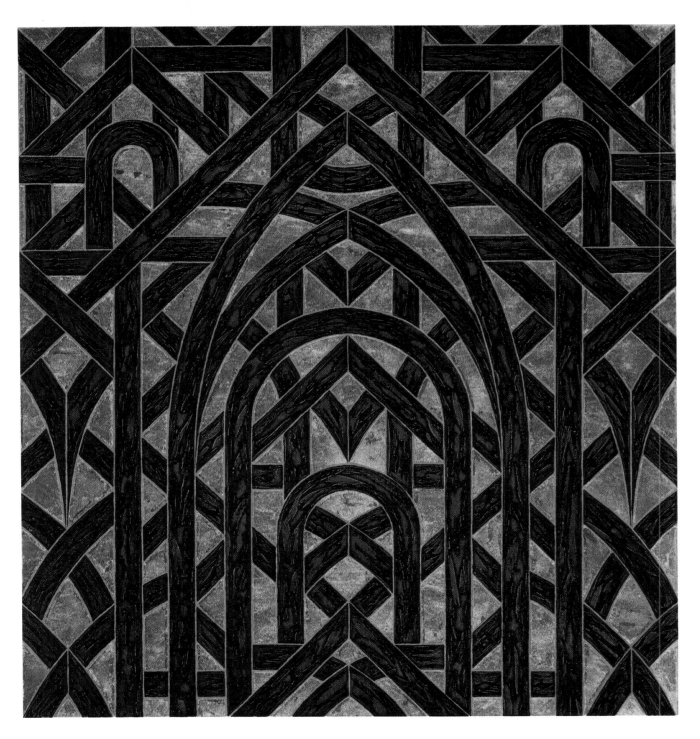

Figure 17. Valerie Jaudon,
Untitled, *1981, etching and
aquatint, printed in color, with
gold leaf hand-additions and
varnish, 26 ¹/₈" x 23 ⁷/₈".
Collection of The Museum of
Modern Art, New York, New York.
John B. Turner Fund.*

they concocted what impressed their (inevitable) detractors as an ephemeral, Disneylike profusion of fun junk.[62]

In this context, Jaudon emerges as a relatively sober and cautious figure, making work that "hedge[d] its bets," by maintaining a dignified "dialogue with the art historical past."[63] Jaudon proved her rapport with others of the Pattern and Decoration group, however, by her beliefs that modernism as we had known it is defunct and that the artist—no longer looking so triumphantly to the future—enjoys a new and liberating prerogative: to raid the modernist visual storehouse at will, along with the resources of premodern, traditional or ethnic cultures, and the image banks of the commercial culture, scrambling any and all preexistent visual codes and devising new admixtures and syntheses. As Jameson has described it, the post-modern is a "force field in which very different kinds of cultural impulses— what Raymond Williams has usefully termed 'residual' and 'emergent' forms of cultural production—must make their way."[64] Huyssen specially isolates Pop art

[62] British critics particularly recoiled at this spectacle of bad taste triumphant. A group show called "Dekor" at the Museum of Modern Art, Oxford, in 1980 elicited remarks like the following: "to knowingly produce kitsch...now that is perverse"; "a celebration of false values, false sentiments...stylistic prostitution"; "kooky, bad-taste artists"; "a puff-pastry of a show." On the other side of the Atlantic, Corinne Robins took up the cry: "the stock of Bloomingdale's and Fiorucci somehow found its way to Soho and 57th Street while we weren't looking and is now taking up a lot of serious gallery space...suddenly the art game in America is becoming just that—a game, rather than the life and death issue which for many people it has been for the last forty years" (Robins, "Late Decorative: Art, Artifact, and the Ersatz," *Arts*, 55, no. 1 [September 1980], 150). Schjeldahl's final judgment would be that " 'P & D' proved less successful in seriously elevating decoration than in insouci-antly debasing art" (Peter Schjeldahl, "Oh So Pretty!" *Village Voice*, 9 November 1993, 89). The Pattern and Decoration group succeeded also in serving to open one of the central veins of New York's new, resolutely lowbrow, East Village scene of the 1980s—that associated with figures such as Kenny Scharff, Rodney Alan Greenblatt and Keith Haring.

[63] Robert Atkins, "Decorative Inclinations," [San Francisco] *Bay Guardian* (date unknown) 1980.

[64] Jameson, "Postmodernism," 57.

Figure 18. (right) Cynthia Carlson, Gingerbread House, *1977, wood, acrylic, urethane foam and fiberglass, 156" x 78" x 156". Courtesy of the artist.*

Figure 19. (left) Robert Kushner, More Fairies, *1980, acrylic on cotton, 99 1/2" x 132 1/2". Courtesy of Holly Solomon Gallery, New York, New York.*

[fig. 20], viewed in its fullest scope, as "the context in which a notion of the post-modern first took shape," in view of the fact that "the most significant trends within postmodernism have challenged modernism's relentless hostility to popular culture."[65] In her own way, Jaudon shared the enthusiasm of her cohorts for Pop art and the kinds of artistic freedoms it spelled. "They were very experimental," she remarked of the Pop artists, "very shifty, not just in their take on culture, but also formally, all that seriality, reproduction, repetition. I have a real appreciation for that."[66]

Postmodernism, broadly considered, encompasses music alongside other cultural pursuits, and although it was not a focus of Jaudon's or of most other artists associated with the Pattern and Decoration movement, significant parallels exist between the New Decoration and the new sounds of postmodern music.[67] "New sounds" is the critic John Schaefer's term for the contemporary music mostly hailing, in the United States, from California and from New York City's "downtown" music community.[68] The downtown scene was so designated to differentiate it from another, established

[65] Huyssen, "Mapping the Postmodern," 188. "The great divide that separated high modernism from mass culture...no longer seems relevant to postmodern artistic or critical sensibilities." Huyssen continues, "...the primary place of what I am calling the great divide was the age of Stalin and Hitler when the threat of totalitarian control over all culture forged a variety of defensive strategies meant to protect high culture in general"; the views of Greenberg and Adorno "cannot be totally divorced from the pressures of that era" (ibid. 196-197). Jameson also identified a "fundamental feature" of Postmodernism as "the effacement...of the older (essentially high-modernist) frontier between high culture and so-called mass or commercial culture," noting that "aesthetic production today has become integrated into commodity production more generally" (Jameson, "Postmodernism," 54, 56).

[66] Kaneda, "Valerie Jaudon," 42.

[67] The relation between Pattern Painting and minimalist music was mostly overlooked by critics, though Perreault noted in passing that "musicians like Steve Reich are breaking down the hierarchies between rock and classical music. One could compare pattern paintings to Reich's shimmering shifting tapestries of sound, often built of only a few repeated chords" (Perreault, "The New Decorativeness," 49).

avant-garde, dubbed the "uptown" scene. Prominent among downtown artists and their California ilk were Philip Glass, Steve Reich, Terry Riley, LaMonte Young and Brian Eno; among uptown artists major names included Elliot Carter and Milton Babbit. A comparison might be drawn between the situation of these latter figures, who had been sanctioned by critics and the academy as the true avant-garde, and that of artists such as Kenneth Noland, Morris Louis and Jules Olitski, who had been anointed by Greenberg's acolytes in the late 1960s and 1970s as the legitimate heirs of the modernist tradition, but whose alleged preeminence was increasingly subject to question.

What characterized the so-called Minimalist music of Glass, Riley, Reich and Young, which emerged in the 1960s, was the use of strongly repetitive, often cyclic or additive, pattern-based musical structures, realized by electronic means and/or by non-traditional uses of traditional musical means. As a factor of their orientation toward rhythmic patterns, these composers were distinguished by their profound interest in various great, non-Western musical traditions, notably including those of India and, in the case of Reich, also West Africa and Indonesia.[69] What further came to differentiate these figures and, even more so, such California-based composers as Eno and Harold Budd, was a more ingratiating or at least welcoming attitude toward the listening public than that evinced by the avant-garde in its pursuit of difficult, often dissonant musical forms. "The element of tonality is common to all of the California-based composers, who are concerned with beautiful melodies to a degree that no self-respecting academic composer could tolerate," noted Schaefer.[70] And though the early, most stringent work of the Minimalists generally dismayed many listeners at first, by the mid-1970s Glass and Reich had attracted a sizable, often young public, including, in the case of Glass especially, numerous key members of the visual arts community, such as Laurie Anderson (a crossover figure) and Sol LeWitt.[71] Ever since Glass's monumental opera "Einstein on the Beach" of 1976, music with complex

[68] California played a catalytic role in the emergence of the new music, as it did in that of Pattern and Decoration. As the composer Ingram Marshall put it, "There's a much looser environment, so a composer could more readily succumb to his or her hedonistic impulses in California, without worrying about whether he or she were falling into the proper niche of history" (John Schaefer, *New Sounds: A Listener's Guide to New Music* [New York: Harper and Row, 1987], 35). Also important is that, far more so than in the East, "Ethnomusicology…has for many years been a frequently appearing course in California schools" (ibid., 119).

[69] "The importance of ethnic traditions to new music as a whole can hardly be overstated" (Schaefer, *New Sounds*, 134). (As is evident from these footnotes, I—as a, however appreciative, neophyte in these matters—rely heavily for my view of new music on Schaefer's pioneering study.)

[70] Schaefer, *New Sounds*, 35.

[71] In 1973, Anderson met Glass and "joined other artists who sat in on Phil's rehearsals, which resembled meditation exercises (like Sol LeWitt said, 'I do my best work at Phil's rehearsals')" (Laurie Anderson, *Stories from the Nerve Bible: A Retrospective, 1972-1992* [New York: Harper Perennial, 1994], 28).

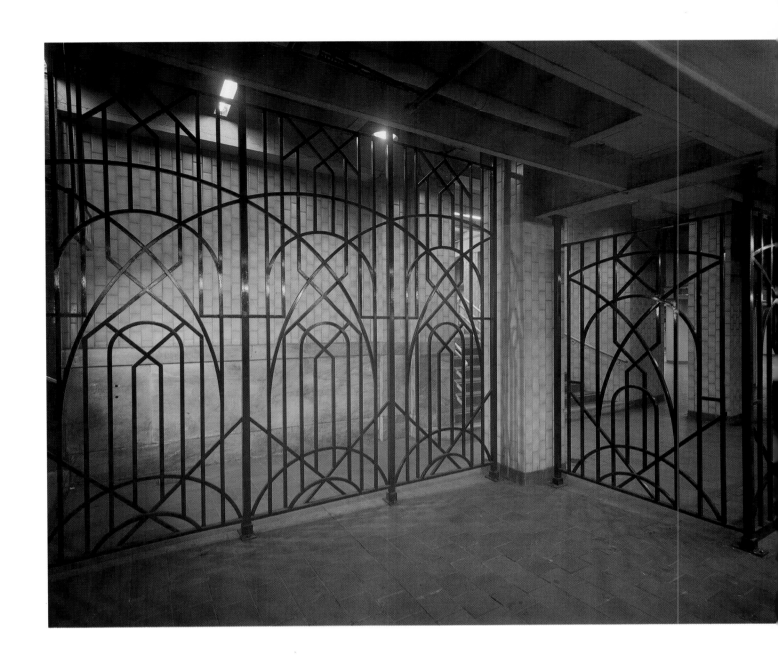

Figure 21. Valerie Jaudon,
Long Division, *1988,*
fence, painted steel, 12' x 60'.
MTA Lexington Avenue and
23rd Street subway station,
New York, New York. Collection
of the New York City Transit
Authority, New York.

"interlocking instrumental patterns, pulsating rhythms and recognizable melodies has become one of today's most often heard" aural modes.[72]

The crisis of modernism was significantly also a crisis in the relation of art and society.[73] The new music composers, like the new decorators, generally aimed to reengage that general public which the avant-garde had long alienated or neglected (insofar as it could financially sustain such a stance). New music evinced its rapport with a mass audience by looking to foreign music traditions which, however sophisticated, often held a mass as well as an elite appeal—a search they mounted in common with some influential mass market or pop musicians of the day.[74] Jaudon's practice may be compared with that of certain of these new composers not only by its considered transformations of the arts of non-Western cultures marked by their genius for patterning, but also by the somewhat foreign, yet audience-pleasing beauty of much of the results. And this unabashed desire to delight would understandably meet with an approving response from numerous architects and public officials responsible for commissioning art for public sites. In realizing such attractive amenities as a patterned metal fence in a New York City subway station (at Lexington Avenue and 23rd Street) in 1988, an elegantly designed, granite-blocked municipal plaza (at New York's downtown Police Plaza) in 1989, and an inviting garden, *Blue Pools Courtyard*, for the Birmingham [Alabama] Museum of Art in 1993 [figs. 21, 23, 24], Jaudon demonstrated a mentality antithetical to the alienated modernist stance exemplified by, say, Richard Serra's notorious "iron curtain," the *Tilted Arc* of 1981 [fig. 22] (removed by public demand from New York's downtown Federal Plaza). Although the effect of Jaudon's projects and paintings can be one of

[72] Schaefer, *New Sounds*, 70.

[73] Huyssen makes this point, while adding that "modernism's running feud with mass society and mass culture as well as the avant-garde's attack on high art as a support system of cultural hegemony always took place on the pedestal of high art itself" (Huyssen, "Mapping the Postmodern," 218).

[74] It will be remembered that the great sitarist Ravi Shankar first found a public in the United States mostly among rock music's audience, and that Beatle George Harrison introduced sitar music to a mass public in the West with his "Norwegian Wood" song of 1965.

Figure 22. Richard Serra, Tilted Arc, *1981, steel, 12' x 120'. Jacob K. Javits Federal Building / 26 Federal Plaza, New York, New York.*

opulence, they present the public not only with manifest pleasures, however, but also with unfamiliar demands, just as the music of the Minimalists did.

To conclusively demonstrate what he viewed as the ultimate limitations of the decorative, Gombrich compared its characteristic structures with those of classical music, assessing the relative, potential rewards each mode of expression holds in store for its audience. We expect not only repetition in music, but also change, he pointed out, while sketching the characteristic compositional structure of Western music: its movement from the tonic to the dominant and back again in a closed circuit roughly approximating the normally closed, plot-based (and so, in a loose sense, violent) structures of Western literature. "Movement away from the tonic is experienced as tension, returning as a home-coming, a resolution...a feeling of 'journey's end'." Regretfully Gombrich determines, "there is no valid parallel in the art of design to the way the classical composer develops a theme."[75] Gombrich overlooks other highly developed musical traditions of the world, however—such as those of northern India with the dizzyingly complex, cyclic and additive rhythm patterns of their ragas and talas—which offer other, far different rewards through a structure more continuous or open-ended than that of Western classical music. Here we find the best parallel to that "*amor infiniti*" or love of the infinite that Gombrich aptly identified as the ruling passion of the decorative artist.[76] (And to Jaudon, for one, the infinite repeatability of pattern was positively integral to its appeal.[77])

One consequence of the pronounced repetitiousness of decorative patterning is that Western viewers must look at it differently than they are used to looking at painting. Gombrich understood as much: "Painting, like speaking, implicitly demands attention whether or not it receives it. Decoration cannot make this demand. It normally depends for its effect on the fluctuating attention we can spare while we scan our surroundings." Those individual motifs and isolated details, so vital to received compositional structures, are effectively devalued through the unremitting repetition characteristic of decoration; it offers rather "a feast for the eye without demanding that we should taste of every dish."[78]

[75] Gombrich, *Sense of Order*, 298, 300. " 'How astounding'—says Schopenhauer rightly—'that the change of a semitone, the entry of the minor third instead of the major, produces in us immediately and inevitably a feeling of anxiety and unease from which we are released with equal immediacy by the major!' " (ibid., 299).

[76] Ibid., 80.

[77] Among her "rules for painting," Jaudon explains in conversation, was that the image "has to have the potential for going on indefinitely, for being continuous.... It couldn't be finite." By this rule she meant to distinguish herself from "form-giver" notions of the artist, such as that advanced by LeCorbusier (Interview, 21 June 1994).

[78] Gombrich, *Sense of Order*, 116, 103.

Figure 23. (above) Valerie Jaudon, Reunion, *1989, paving plan, brick and granite with inlaid granite floor, 3.5 acres, 34' diameter, respectively. Police Plaza/ Municipal Building, New York, New York.*

Figure 24. (right) Valerie Jaudon, Blue Pools Courtyard, *1993, garden, pool and bench design, plantings, bluestone, brick, tile, cast iron, 70' x 80'. Birmingham Museum of Art, Alabama; Edward Larrabee Barnes, architect.*

Supporters of Pattern Painting also recognize that it invited or compelled an unaccustomed kind of attention from the viewer. Noting that the structure most elemental to pattern is the grid, Goldin proposed, interestingly, that "grids and compositions are cues to different mobilizations of self…. Compositions breed involvement, intimacy and references to self. Grids generate a greater emotional distance—a sense of the presence of objective pervasive law." For the viewer, "the characteristic response to patterns and grids is rapid scanning," and scanning "contains an element of search, and unsatisfied search at that, since it implies a restless refusal to focus and an attempt to grasp the nature of the whole." Finally, "the enjoyment of patterns and grids, so often linked to religion, magic, and states of being not-quite-there, requires an indifference to self-assertion uncongenial to most Westerners."[79] (Numerous artists interested in geometric patterning, prior to the Pattern Painters—Ad Reinhardt, Agnes Martin and Alfred Jensen, to name a few—have had an attendant interest in Eastern philosophy and/or esoteric systems.[80])

Fortunately for Jaudon, her development of Pattern Painting occurred at a time of growing public interest in those "states of being not-quite-there" available through Yoga and other, ancient Eastern systems of meditation. Appealing to that general curiosity, Perreault once referred to Pattern Painting as "Visual Yoga," reasoning that pattern, "being non-iconic, displaces the ego," and invites a kind of simultaneous "concentration and letting go" akin to meditative states.[81] Jaudon's compositions of the 1970s through the mid-1980s are in fact iconic, insofar as they typically have a center, but they undercut the impression of centrality by diffusing that center through a radiant, all-over, largely non-hierarchic pictorial structure. From decoration's "tendency toward decentralization…through the agency of pattern, its diffuse rather than forceful effect," Jeff Perrone inferred a non-assertive or non-egoistic mode of creation and even ventured that it is "impossible to reconcile the decorative with any form of violence or aggression."[82]

Perreault saw the meditative aspect of Pattern Painting as yielding a "soothing" experience for artist and viewer alike. And Gombrich pointed out that there is something primally reassuring about pattern as an articulation of "the sense of order." He described as a "universal tendency," moreover, "the assumption of continuity. We expect things not to change unless we have evidence to the contrary.

[79] Goldin, "Patterns, Grids, and Painting," 51, 54. Elsewhere Goldin argued that "the experience of decoration is typically celebrant and contentless, like the psalmist's praise beyond reason" (Goldin, "Matisse and Decoration," 58).

[80] Regarding the mystical dimensions of the grid, see Rosalind E. Krauss, "Grids," rpt. in her *The Originality of the Avant-Garde and other Modernist Myths* (Cambridge, Ma.: M.I.T. Press, 1985), 8-22.

[81] John Perreault, "Visual Yoga," *Soho Weekly News*, 10 November 1977, 25.

[82] Jeff Perrone, "Philadelphia," *Artforum*, 18, no. 3 (November 1979), 81.

Without this confidence in the stability of the world we could not survive. Our senses could not cope with the task of mapping the environment afresh every moment." There may indeed be something deeply restful or, more negatively expressed, tranquilizing or regressive about the contemplation of pattern.[83] (For that matter, the inveterate grid-painter Martin professed that she aimed above all to induce a blissfully "untroubled mind" in the viewer, as in herself.[84]) But patterning schemes may have challenging aspects also. And in Jaudon's case, the challenge for the viewer lies especially in the subtle, yet unmistakable suggestions of a profound *dis*order lurking within her semblances of perfect order.

Once viewers attempt methodically to trace and retrace the pathes of the stripes meandering over Jaudon's canvases, such as *Pantherburn*, they discover that many of those pathes are blocked or discontinuous; that the labyrinth is rife with deadends. The critic John Yau noted the "confounding" aspect of Jaudon's patterns, a "discontinuity…which makes reading the over-under connections difficult, makes the work seem hermetic, and teases us with geometric impossibilities. All that precision turns out to be ultimately elusive, and one has the feeling of wandering in a maze from which there is no exit," an experience of "near-claustrophobia."[85] Rickey observed, moreover, that Jaudon at once "sets up order and subverts it with chaotic filaments which misconnect, suspiciously testing our eyes and ability to make connections."[86]

One theory concerning the significance of the elaborate interlace and intricate knotwork found in ancient ornamental styles is that, like mazes, they "were once connected with the hope of confusing pursuers."[87] To confuse or confound the viewer has all along been one of Jaudon's aims; she talks of toying with her audience's presuppositions of what art is or should be and of making geometry that looks one way but acts another, prompting double-takes by the viewer.[88] When asked which artists had particularly influenced her, she cited those who "deal with a certain conceptual dissonance, that set you up to read things one way and then force you to change direction," naming Hesse and the composer Charles Ives among others.[89]

[83] Gombrich, *Sense of Order*, 107. Gombrich notes that "the enjoyment of simple rhythms and exuberant flourishes is closely associated with what psychoanalysts call regression" (ibid. 19).

[84] See Anna C. Chave, " 'Agnes Martin: Humility, the Beautiful Daughter…'," in *Agnes Martin*, ed. Barbara Haskell (New York: Whitney Museum of American Art, 1993), passim.

[85] John Yau, "Valerie Jaudon at Holly Solomon," *Art in America*, 67, no. 3 (May/June 1979), 144.

[86] Carrie Rickey, "Decor," in *Dekor*, exhibition catalog (Mannheim, Germany: Mannheimer Kunstverein, 1980), 9. Remarked another critic, "Jaudon seems to be setting out an architectural plan for an M.C. Escher edifice—apparently logical plans that just won't work" (Martin Bright, *Pattern Painting* [Bracknell, Berkshire, England: South Hill Park Arts Centre, 1981], n.p. [brochure]).

[87] Gombrich, *Sense of Order*, 263. (He is skeptical of this theory.)

[88] Interview, 21 June 1994.

[89] Paparoni, "Valerie Jaudon," 73.

From this perspective, Jaudon likes to think of her own art as incipiently political, as having a subversive moment.[90]

Historically, abstract art has proven a notably unstable, if not necessarily ineffectual, site for conveying political messages. By virtue of the intrinsic ambiguity or indeterminacy of its referents, it is highly vulnerable to "misreading" and cooptation. That foible of abstraction, among others, propelled many feminists to turn away from it toward visual modes more amenable to polemic. Martha Rosler, for one, remembers that in the late 1960s feminism "burst like a bomb in my mind. That stopped me from doing abstract painting, because it was then that I realized that I really had a great deal to say and that abstract painting was in fact mute and self-mutilating."[91] But polemical modes have their limitations too, and in Jaudon's view, making an abstract painting means the opposite of staying mute; it means "a chance to speak," to "have my say" in a way that may contribute to "turning things around."[92]

The shocking subject of Taaffe's work is, in short, beauty itself—shocking because of the dangerous optimism this implies in so ferociously skeptical a period as this one.... Not since Frederick Church...has a painter seemed so undaunted by the routine presence of beauty as Taaffe.[93]

Lisa Liebmann, "Taaffe's Temple," 1994.

That a serious critic could write about a young male painter in 1994 as if he had single-handedly uncovered the manifold beauties and pleasures of the decorative, at least for a contemporary audience—that she could write as if Jaudon had never existed, in other words—might signal that nothing has really turned around. No critics have ever marveled at Jaudon's "undaunted" forays in the fields of the decorative, calculated the "high price" she "pays for [her] pleasure" or imagined that her studio contains a veritable "world of...anxiety," as Lisa Liebmann gushes about the admittedly talented Philip Taaffe [fig. 25].[94] Such fulsome rhetoric, and the psalm to originality that accompanies it are still ordinarily reserved for male artists, whose excursions into the decorative may still pass as acts of derring-do. One might be tempted to say that Jaudon has deluded herself, then, in imagining that her work has made a difference. Marcia Tucker noted acerbically that some female critics have

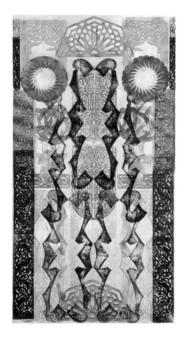

Figure 25. Philip Taaffe, Portal, 1994-1995, mixed media on canvas, 113 1/2" x 58 1/2". Courtesy of Gagosian Gallery, New York, New York.

[90] Kaneda, "Valerie Jaudon," 42.

[91] Cited in Paul Wood, Francis Frascina, Jonathan Harris, Charles Harrison, *Modernism in Dispute: Art Since the Forties* (New Haven, Conn.: Yale University Press, 1993), 160.

[92] Interview, 21 June 1994.

[93] Lisa Liebmann, "Taaffe's Temple," *Elle Decor*, December/January 1994, 30. Taaffe is further identified as "an omnivorous collector of reference books on everything from Hungarian embroidery patterns to Japanese sword-guard designs" (ibid.).

[94] Ibid.

lauded contemporary female artists for having "pioneered the use of a subjective, personal voice; overtly political content;…pattern and decoration; dream images, mythic, and ritual practices; and the dissolution of differences between low and high art. Certainly it seemed as though women had defied the canon and diffused the mainstream by providing men with new stylistic arenas. Unfortunately, it was the men who became famous and reaped the economic rewards of those changes." [95]

Though Tucker's view is all too acute, Jaudon's claims to having had an effect are not idle or ill-founded. And the New Decoration has not been totally forgotten, though it and she have never quite received their due as the generative forces they have been. *New York Times* critic Holland Cotter not long ago remarked that "it's odd that the Pattern and Decoration movement of the 1970's is so little valued at present. Its challenges to male-dominated, Western high art anticipated exactly the issues many younger artists are grappling with today." [96] Well before the term "multi-culturalism" became a watchword in the academy, the Pattern and Decoration group had conceived a vision of multi-cultural, non-sexist, non-classist, non-racist, non-hierarchical art. As for the group's goal of relegitimizing the decorative arts: though it cannot, in truth, assume much of the credit, this revaluation has indeed been in progress since the time the movement coalesced. Serious research on the history of quilts, for instance, has been advancing since the 1970s—as have the prices of those textiles at auction. Fine art museums increasingly acquire decorative art and sometimes integrate it in displays of their painting and sculpture collections. New museums and new museum buildings dedicated to design and craft have opened (sometimes with women at the head). And numerous graduate programs for the study of material culture and the decorative arts have been established.

In the 1970s some critics noted that the Pattern and Decoration group was unique as a widely recognized art movement that had numerous women at its forefront. [97] Kay Larson penned in 1980 a general article on the contemporary art scene that proclaimed, "For the First Time Women are Leading…Not Following." [98] It now seems that the fact of the female leadership of the Pattern and Decoration movement

[95] Marcia Tucker, "Women Artists Today: Revolution or Regression?," *Making Their Mark: Women Artists Move into the Mainstream, 1970-1985*, catalog of exhibition curated by Randy Rosen with Catherine C. Brawer (New York: Abbeville, 1989), 199.

[96] Holland Cotter, "Robert Kushner," *New York Times*, 12 November 1993, c22.

[97] "If pattern painting is the dominant painting style right now…then women have moved solidly into the avant-garde for the first time in art history…. One can't conceive of its emergence prior to the women's movement" (April Kingsley, "Opulent Optimism," *Village Voice*, 28 November 1977, 76). Perreault identified Pattern and Decoration as "the first art movement in which women have figured prominently," noting that Kozloff, Schapiro and Jaudon, had "used the organizational skills they had picked up in feminist politics to encourage a dialogue among artists with shared concerns" (Perreault, "The New Decorativeness," 46).

helped doom it to an abbreviated or discontinuous and sometimes rocky path through the marketplace, cultural institutions and the byways of journalism. But the immense contributions of these and other nervy feminists who jumpstarted and drove a moribund feminist movement in the United States in the 1970s have lately begun to receive some serious, long-deferred credit. Huyssen states plainly that "it was especially the art, writing, film-making and criticism of women and minority artists with their recuperation of buried and mutilated traditions, their emphasis on exploring forms of gender- and race-based subjectivity in aesthetic production and experiences, and their refusal to be limited to standard canonizations, which added a whole new dimension to the critique of high modernism and the emergence of alternative forms of culture."[99] And Susan Bordo salutes the feminists of this period for having "cleared a space, [and] described a new territory, which radically altered the male-normative terms of discussion about reality and experience; they forced the recognition of the difference gender makes."[100] Although she had in mind not artists but scholarly feminists like Carol Gilligan and Dorothy Dinnerstein when she made the claim, it applies nonetheless to Jaudon.

"As a woman I am...outside of the main discourse of history," Jaudon observes, but that displacement now paradoxically has its advantages: "To be inside the main room when the walls are closing in must be an uncomfortable position.... It is much better to be outside the realm of modernist self-reference, to be able to acknowledge complexity, to make art that reflects the multivalent world that we live in today."[101] Looking to unsung modes of cultural production to shape her pictorial vision, Jaudon resolved to change viewers' minds about those ornamental arts' putatively minor and residual status. Looking to engage an audience oblivious or hostile to contemporary art, she employed that famously abstruse vocabulary of geometric abstraction to design and realize public amenities that are accessible, pleasing and functional. Looking to retrieve a function of art long since disavowed by the avant-garde— giving viewers sensual pleasure at a time when (non-exploitive) pleasures are in short

[98] Kay Larson, "For the First Time Women are Leading...Not Following," *Art News*, 79, no. 8 (October 1980), 64-72. "Far from displacing men, female leadership has opened up new freedom for everyone," observed Larson comfortingly (ibid., 64).

[99] Huyssen, "Mapping the Postmodern," 198. The pathbreaking article pointing to the feminist movement's key role in effecting crucial cultural, ideological and epistemological shifts was Craig Owens's "The Discourse of Others: Feminists and Postmodernism," rpt. in *The Anti-aesthetic: Essays on Postmodern Culture*, ed. Hal Foster (Port Townsend, Wa.: Bay Press, 1983), 57-82. The postmodern condition has been experienced largely as a "loss of mastery" on every front argued Owens, and "what if not the emergence of Third-World nations, the 'revolt of nature' and the women's movement—that is, the voices of the conquered—has challenged the West's desire for ever-greater domination and control?" (ibid., 67).

[100] Susan Bordo, "Feminism, Postmodernism, and Gender-Scepticism," *Feminism/Postmodernism*, ed. Linda J. Nicholson (New York: Routledge, 1990), 137.

[101] "The Question of Gender in Art" (compilation of artists' statements), *Tema Celeste*, 37-38 (Autumn 1992), 57.

supply—she produced paintings, "so flagrantly beautiful…I can barely stand it myself."[102] Looking to seduce viewers with a sense of order that seems reassuringly centered, logical and controlled, she led them instead into a confused yet tantalizing maze of possibilities and deadends; presented them with a metaphorical map of the modern-day world in all its vertiginous perils and terrors, its routine frustrations and its heady potentialities.

Feminist theories, like other forms of postmodernism, should encourage us to tolerate and interpret ambivalence, ambiguity, and multiplicity as well as to expose the roots of our needs for imposing order and structure no matter how arbitrary and oppressive these needs may be. If we do our work well, reality will appear even more unstable, complex, and disorderly than it does now.[103]

Jane Flax, "Postmodernism and Gender Relations in Feminist Theory," 1990.

Let the record show that the disorderly order crafted by Valerie Jaudon has done, and does, its work well.

I am indebted to Cynthia Carlson, Joyce Kozloff, Barbara Schwartz and above all Valerie Jaudon for sharing their perspectives on the Pattern and Decoration movement with me. Jaudon has my gratitude also for allowing me access to her substantial archives and for graciously tolerating my repeated intrusions in her studio.

[102] Interview, 21 June 1994. In the *Mediation of Ornament*, Grabar called special attention to pleasing as a central function of decoration, and an astute reviewer remarked on this "use of a notion almost absent from art historical discourse: visual pleasure" (Margaret Olin, "Book Reviews," *Art Bulletin*, 75, no. 4 [December 1993], 731).

[103] Jane Flax, "Postmodernism and Gender Relations in Feminist Theory," *Feminism/Postmodernism*, ed. Nicholson, 56.

A Chronological Analysis of the Paintings: 1973–1995

Paintings from 1973–1979

Toomsuba, 1973

Beginning in 1973, Jaudon constructed her paintings with individual blocks 2" to 8" long and 2" wide, which were painted in a range of 250 acrylic colors. The blocks were arranged both intuitively and randomly on overlapping horizontal, vertical, diagonal and circular grids. Their thick brush strokes were painted without masking out unpainted areas, a technique Jaudon continued until recently. Jaudon titled all of her works after the names of towns in her native Mississippi until 1985.

Natchez, 1975

In 1974 and continuing through 1978, Jaudon eliminated color in her work; paintings from this period are black, white or metallic monochromes. Works from 1975 and 1976 are asymmetrical, although a system of grids was still employed in composing these works. The bare canvas outlines visible between blocks of pigment become an important structural element and give the paintings a pronounced linear quality.

Big Biloxi, 1979

In 1976 Jaudon established a greater order in the multi-directional grid system by replacing the asymmetry of her earlier paintings with a symmetrical structure based on mirroring modules. Thus the canvases do not have an obvious top and bottom orientation. In square-format paintings, the modules are grouped in four, nine or sixteen; in rectangular paintings, up to twenty-four are used.

Toomsuba, *1973,*
acrylic on canvas,
72" x 72".
Collection of the artist.

Jackson, *1976, metallic pigment in polymer emulsion and pencil on canvas, 72" x 72". Hirshhorn Museum and Sculpture Garden, Smithsonian Institution. Gift of Joseph H. Hirshhorn, 1977.*

*Cybur, 1975, oil on canvas,
72" x 72". Collection of
Volvo North America
Corporation, acquired by
Pehr Gyllenhammar.*

Bellefontaine, *1976,*
oil and metallic pigment on
canvas, 72" x 72".
Holly Solomon Gallery,
New York, New York.

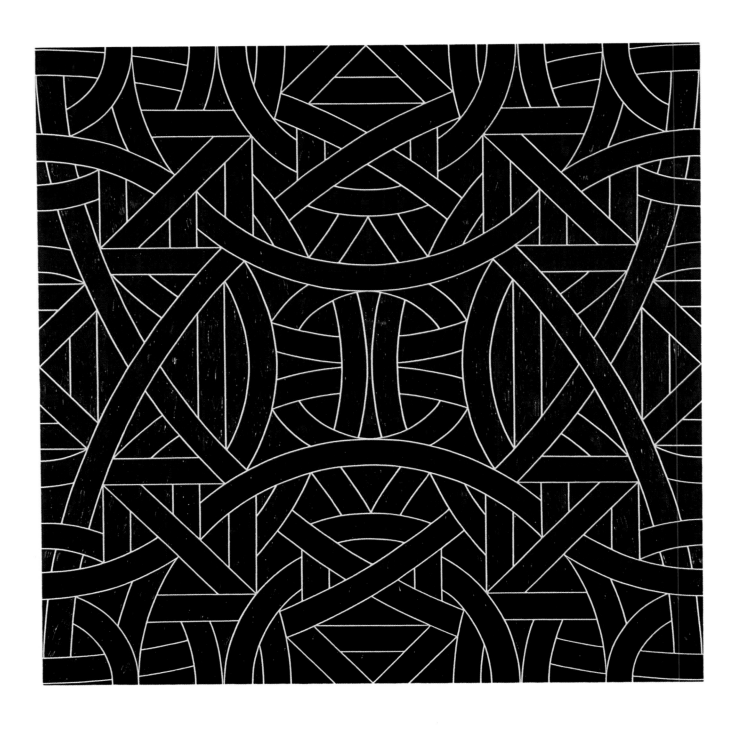

Big Biloxi, *1979,*
oil on canvas, 80" x 80".
Collection of Michael and
Juliet Rubenstein.

A Chronological Analysis of the Paintings: 1973–1995

Paintings from 1979–1985

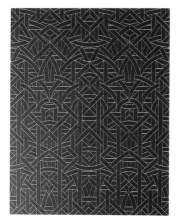

Pantherburn, 1979

Jaudon maintained her monochromatic color palette through 1979, and her paintings began to have a definite vertical orientation. She continued to use modular symmetry and introduced a two-part symmetry with the units mirroring themselves along the central vertical axis. The small structural blocks of earlier works lengthened into bands of color which give the paintings a strong architectural presence. Jaudon also employed rounded and pointed arches which correspond to Romanesque and Gothic arches, respectively.

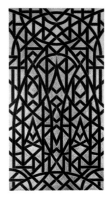

Big Springs, 1980

In 1980 and 1981 Jaudon intensified the existing components of her works through the addition of a second color which also supplied the two-part symmetry and arch structure with a greater sense of spatial development. The spatial and architectural complexity of the works increased during this period.

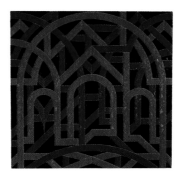

Caledonia, 1982

Jaudon's work from 1982 through 1985 shows a marked break with her previous work. Not only did she reject the modular symmetry which played such a vital role in earlier paintings, but she also expanded her palette to include three colors; one for the background and two for interweaving bands. In some paintings gold leaf was applied over either the foreground or middle ground bands or the background. The spatial development is articulated through references to linear perspective in the arches and through a stronger use of diagonals.

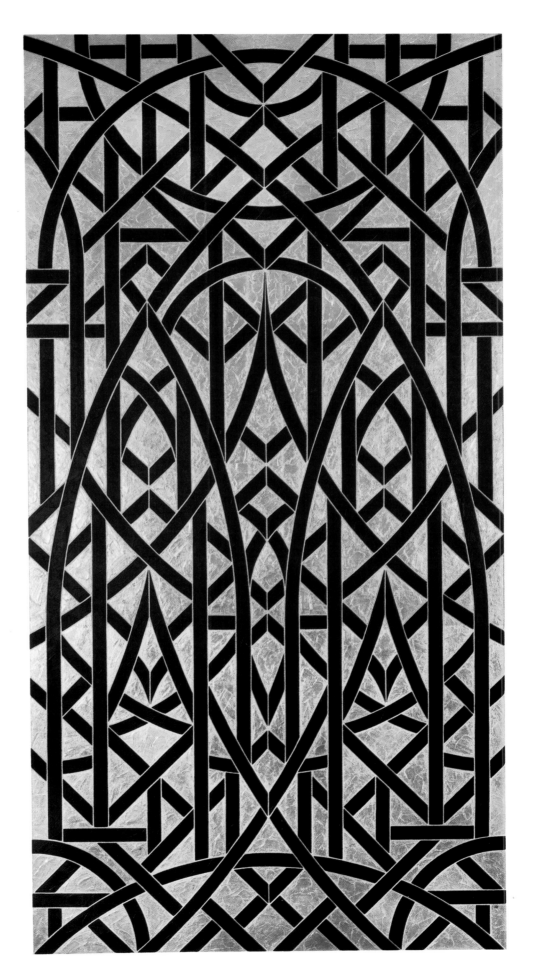

Big Springs, *1980,*
gold leaf and oil on canvas,
96" x 48". Collection of
the artist.

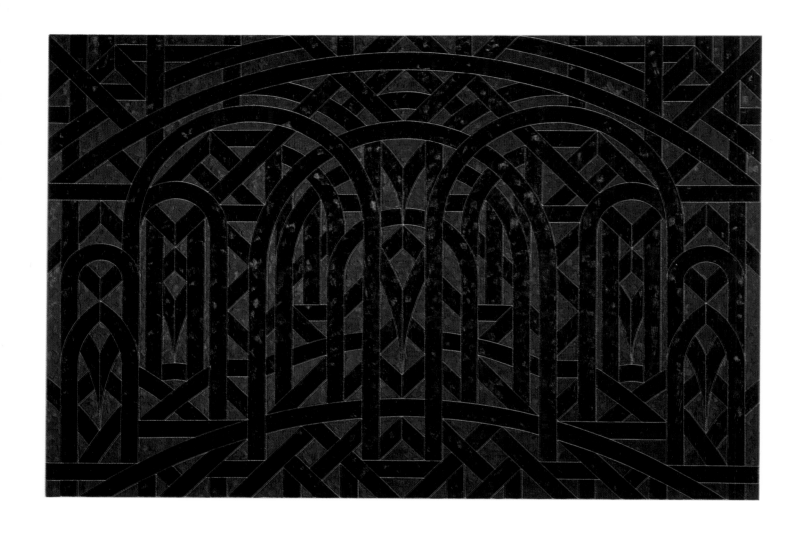

Arcola, *1982,*
oil on canvas, 81" x 120".
Sidney Janis Gallery,
New York, New York.

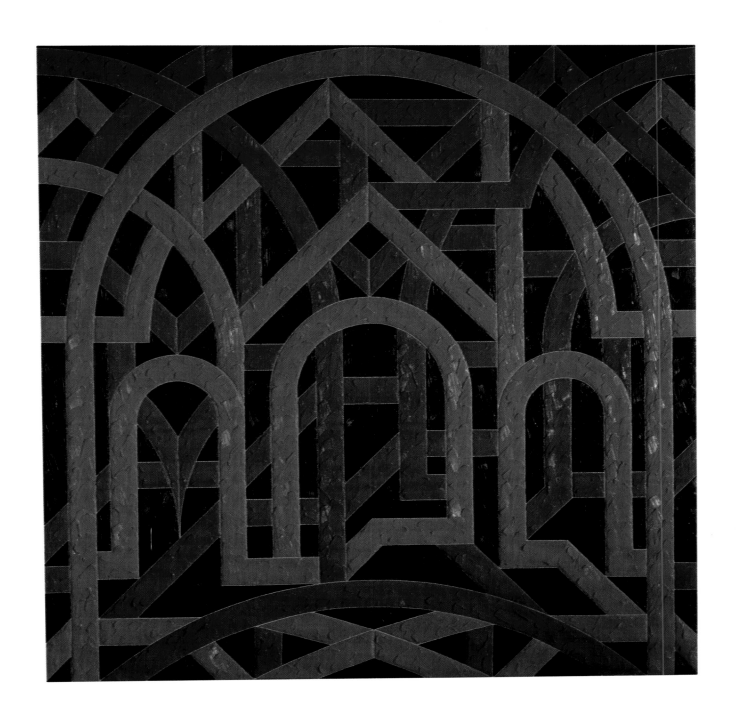

Caledonia, *1982,*
oil on canvas, 72" x 72".
Collection of Leonard and
Stephanie Bernheim.

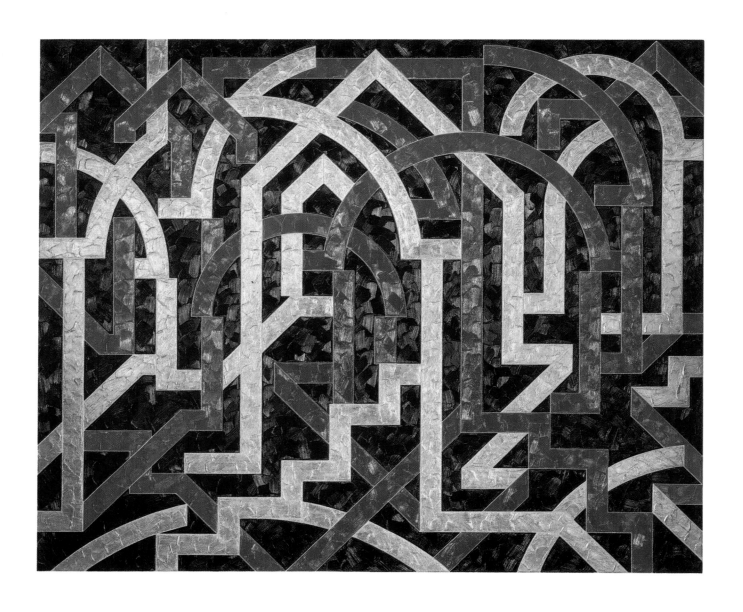

Tallahatchie, *1984,*
gold leaf and oil on canvas,
80" x 96". Sidney Janis
Gallery, New York, New York.

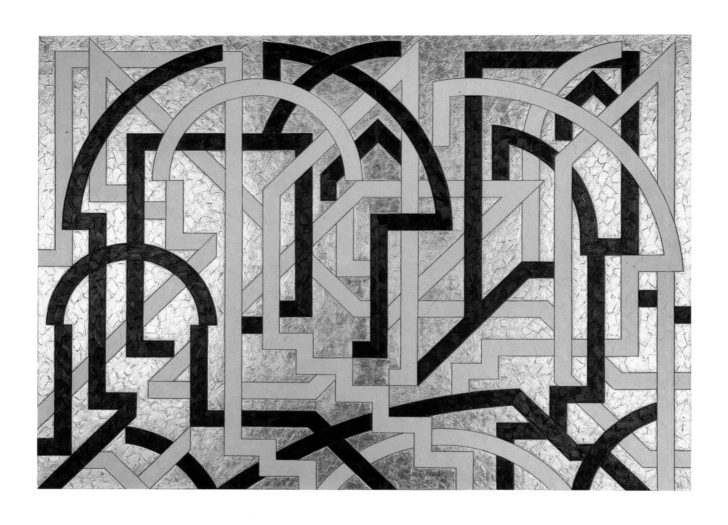

Egremont, *1985,*
gold leaf and oil on canvas,
83" x 115". Sidney Janis
Gallery, New York, New York.

A Chronological Analysis of the Paintings: 1973–1995

Paintings from 1985–1989

Pharsalia, 1985

In 1985 Jaudon fractured the architectural system which she had cultivated during the preceding seven years. The arches disappeared and the paintings became spatially flatter and more geometric. These paintings continued to be limited in palette to three colors, but the colors themselves became more subdued. Also, Jaudon ended the practice of titling her works after towns in Mississippi.

Prime, 1986

All of the paintings made in 1986 are square in format and consist of three colors: a primary hue, metallic silver and black. The bands of color form simple although often broken geometric shapes arranged on a banded grid inscribed on the background color.

Grade, 1988

From 1987 through 1989 Jaudon continued to employ a square format with the background inscribed with a banded grid. Backgrounds are a single bright color and foreground bands, which depict simple geometric forms, are black and white. Although the overall geometric composition of the bands is more simplified than in previous works, the bands themselves are more complex. She often divided the bands into black and white "dots" and "dashes," which gives them a greater dynamic character.

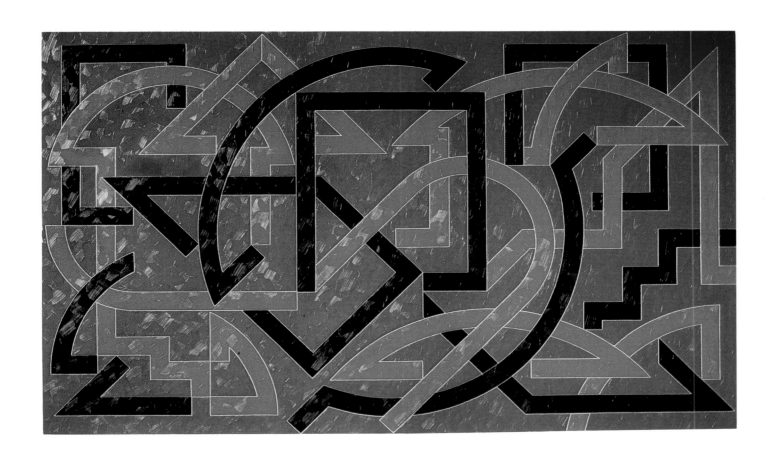

Pharsalia, *1985,*
oil on canvas, 72" x 120".
Collection of Ellen and
Max Palevsky.

Aquilo, *1985,*
oil on canvas, 54" x 54".
Sidney Janis Gallery,
New York, New York.

Prime, *1986,*
oil and metallic pigment
on canvas, 94" x 94".
Sidney Janis Gallery,
New York, New York.

Constant, *1988,*
oil on canvas, 72" x 72".
Collection of Albright-Knox Art
Gallery, Buffalo, New York.
Gift of Seymour H. Knox, 1988.

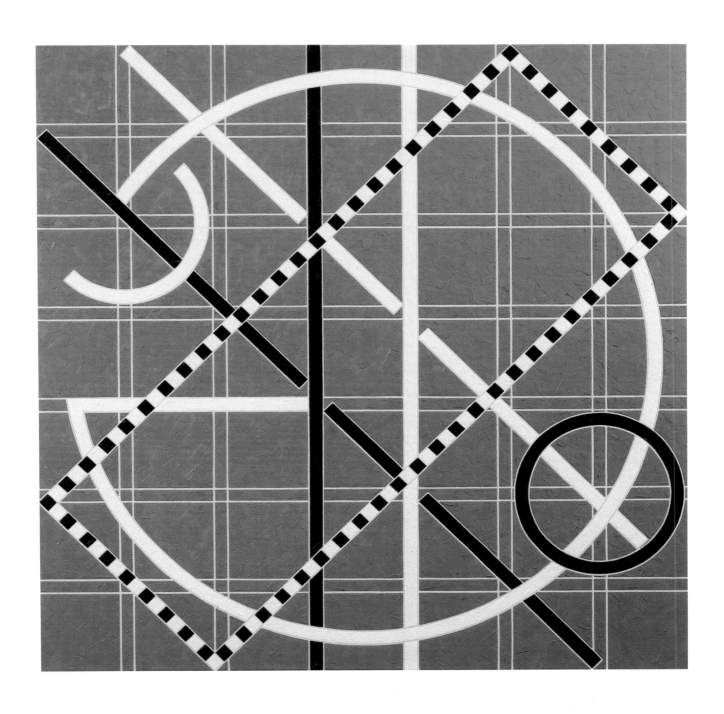

Grade, *1988,*
oil on canvas, 54" x 54".
Private collection.

A Chronological Analysis of the Paintings: 1973–1995

Paintings from 1989–1995

Azimuth, 1990

The growing complexity of Jaudon's paintings from 1989 through 1991 is reflected in a shattering of the grid, the use of complex colors and diversification of the bands. In addition to the "dot" and "dash" bands, Jaudon employed solid black and white ones and also bands in color.

Social Contract, 1992

In her work from 1991 through 1993, the only trace that remains of the inscribed grids is a background comprised of multicolored stripes or checkerboards arranged in color progressions. Foreground bands have a wholly separate identity in relation to the paintings' backgrounds. Vertically oriented ornamental "figures" populate the foreground bands, some of which are symmetrical and others are asymmetrical.

The Best of Everything, 1995

Jaudon's work from 1994 is comprised of ornamental figures which float in the foreground over a background color field. Although the paintings retain a high degree of structure due to the strict verticality of the ornamental figures, there are no longer any explicit references to the grid system that had previously guided her work. The newest work, from 1995, incorporates three overlapping planes. A black, symmetrical, ornamental, figured field is visible in an atmospheric, black-gray "veil" of poured paint. These two planes are unified by a smooth, glossy surface which becomes a third plane.

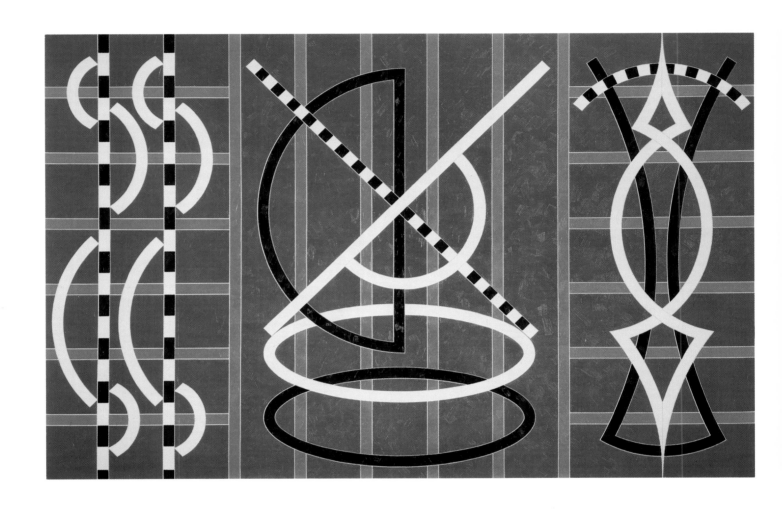

Azimuth, *1990,*
oil on canvas, 90" x 138".
Sidney Janis Gallery, New York,
New York.

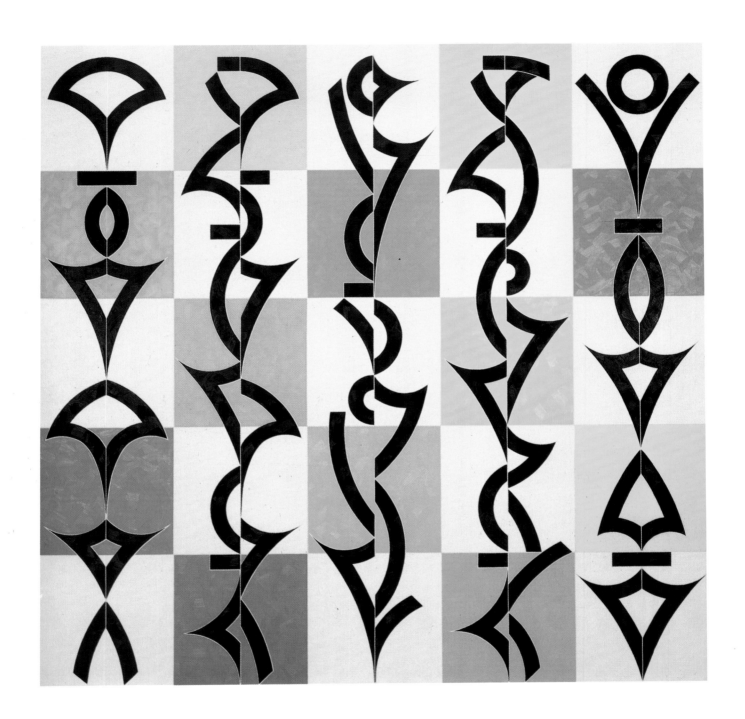

Social Contract, *1992,*
oil on canvas, 94" x 94".
Sidney Janis Gallery,
New York, New York.

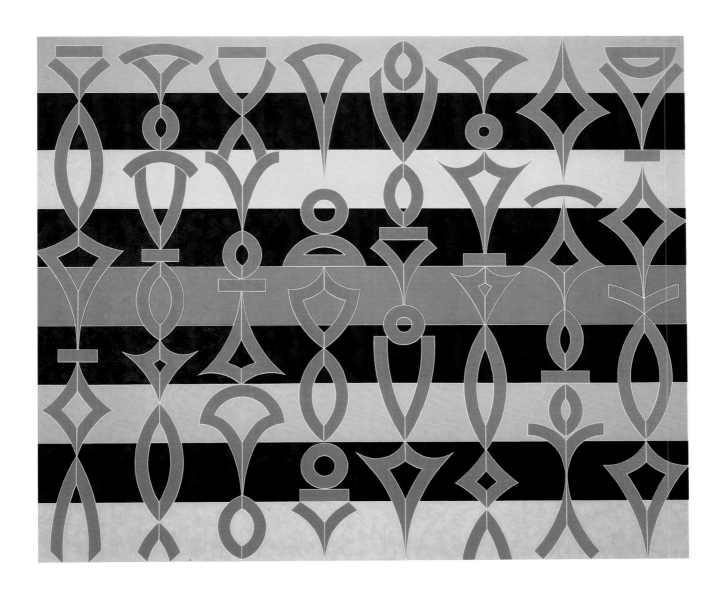

Ballets Russes, *1993,*
oil on canvas, 90" x 108".
Sidney Janis Gallery,
New York, New York.

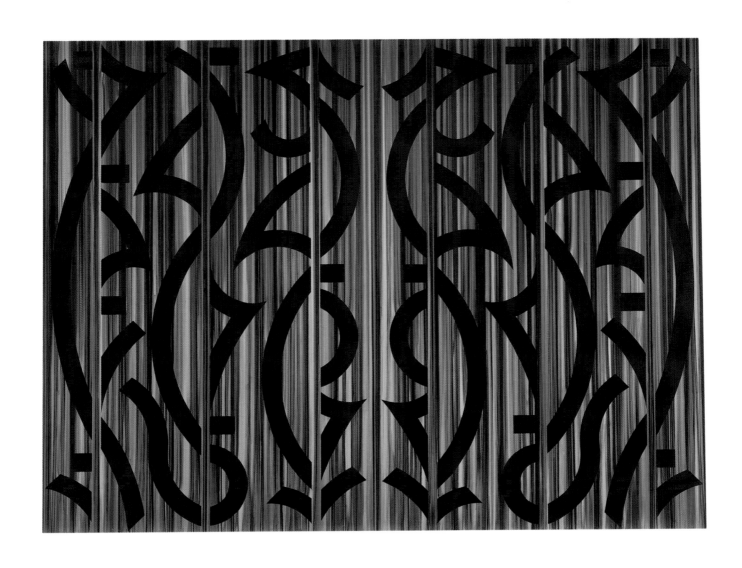

The Best of Everything,
1995, oil and alkyd on canvas,
82" x 106". Sidney Janis
Gallery, New York, New York.

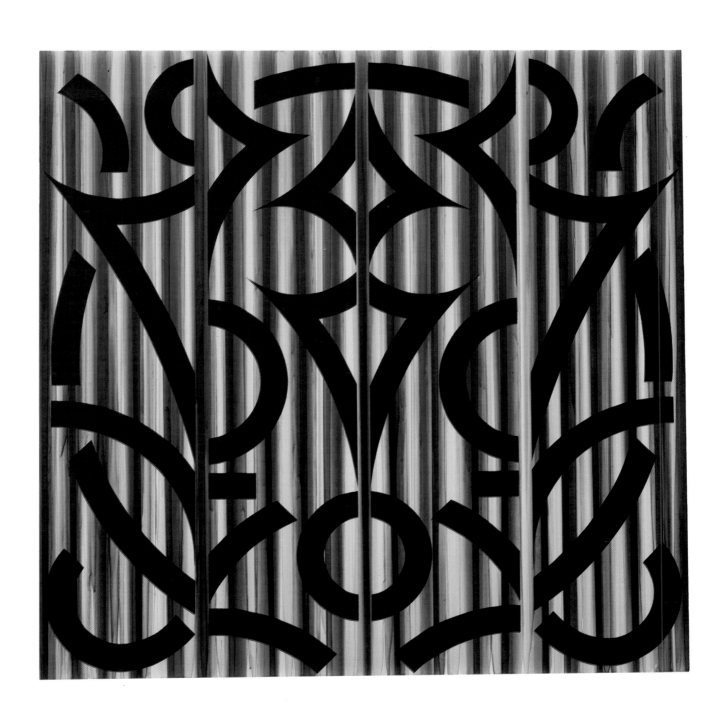

Run Silent, Run Deep,
1995, oil and alkyd on canvas,
72" x 72". Sidney Janis
Gallery, New York, New York.

Interview with Valerie Jaudon

by René Paul Barilleaux

René Paul Barilleaux: *I would like to start by exploring connections between your work created since the late 1980s and issues surrounding the Pattern and Decoration movement to which you were originally linked in the 1970s.*

Valerie Jaudon: In many ways, my concerns today stem directly from my earlier works and some of the issues that surfaced in the seventies regarding the decorative, the feminine, abstraction and painting in general. Ideas like *beauty*. Things that we have a difficult time talking about…they're invisible, but they don't go away. Aesthetics and philosophy seem so uncomfortable dealing with these issues. And now with art under attack both politically and philosophically, the stakes are even higher.

In the seventies, after Minimalism and Conceptualism had closed off all discussion of anything other than themselves, Pattern and Decoration wanted to explore everything at once—complexity, repetition, reference, beauty, disjunction, symmetry, sensuousness. Even though my work has undergone changes since then, I feel that I am still engaged with those very same issues.

RPB: *What about connections in your current work to recent interests in abstract painting?*

VJ: The recent interest in abstract painting has brought to light the fact that the traditional philosophical and theoretical understandings of abstraction are inadequate and need to be expanded. Historically, this situation seems to occur with amazing regularity. That is, older ideas about art—the explanations and interpretations of it— aren't satisfactory for the work that's being done at the present moment. Art, after all, is a language, and languages are constantly changing.

These are very interesting times. Today abstract painters are working with the conventions of painting in a "grammatical" sense. There is an awareness of the devices of abstraction—separating, deconstructing, recombining, reconstructing, bracketing the intuitive processes. There's a lot of thinking going on right now, a lot of excitement.

The most persistent issue for me appears to be a rather stubborn idea that I have about *making* an abstract painting. I could never bring myself to think of abstraction as a war waged against realism. Or, for that matter, a reduction toward the *essence* of anything.

I've always thought about my painting in a much more positive and productive way. For me, an abstract painting is clearly a work of representation, but of a very complex sort. It has more to do with *how* we see than what we see.

RPB: *When did you first become interested in art?*

VJ: That's a very complicated question. My interest in art has a clear beginning—second grade—Ella Darling Elementary in Greenville, Mississippi. From my first class with our art teacher, Maxine Holcomb, I was hooked. Growing up in Mississippi in the fifties, I saw very few "real" paintings except, of course, portraits and paintings of magnolias in the bank on Main Street. There were no museums as far as I knew; I spent hours in the library looking at books on Van Gogh, Gauguin, the Post-Impressionists and Albert Pinkham Ryder. I also copied figure drawings by Michelangelo, Leonardo, Albrecht Durer and Edgar Degas. Their work looked fresh and unfamiliar to me. Reproductions of religious works didn't really interest me—they reminded me of Sunday School. So much for medieval and Renaissance art. But, of course, I was only in elementary school. It all changed later. That's the wonderful thing about art. You can change your mind about it any time.

RPB: *So when did you finally see "real" painting?*

VJ: Seeing an actual painting was a different and wonderful experience for me. I was nineteen when I saw my first Van Gogh painting in The Museum of Modern Art. By the time I got to it, I was so overwhelmed by everything else in the museum that the Van Gogh took a back seat.

I went to art school in Mississippi, Memphis, Mexico and London, and along the way I traveled as much as I could. I saw every museum, archeological and architectural site that crossed my path. Going from Greece to Pompeii to Morocco to Stonehenge, I devoured rather than discriminated. Everything outside of Mississippi seemed foreign and exotic—I had a lot of catching up to do.

RPB: *Which artists influenced you first?*

VJ: Influences are difficult to pinpoint. There are artists who made great paintings that I admire and love to look at, but I'm not necessarily interested in their work in connection with my own. Some specific aspects of other artists' work that I can identify in my first serious work would include the building block brush strokes of Cezanne

and Seurat; and the clear, legible abstract elements—like an alphabet—of Piet Mondrian, Theo van Doesburg, Paul Klee, Jackson Pollock and Agnes Martin. Also, I admired work which avoided "drawing in paint"...the sort of thing abstract artists were supposed to do. Picasso, de Kooning and Pollock did it really well, and I felt that I didn't have anything much to add. I was interested, in fact, in finding a way around that. *Bravura* markmaking was something that I felt would limit me rather than allow me to grow. Instead, I was attracted to artists who were more "device-oriented," more systematic, more logical. They were people who used repetition and anonymity but did it in a way that was engaged and inventive. Sol LeWitt, Donald Judd, early Larry Poons's dot paintings, Andy Warhol, Eva Hesse, Roy Lichtenstein, Frank Stella's black paintings, Jasper Johns's alphabets and Matisse's cut-outs come to mind.

RPB: *Whose work do you admire now?*

VJ: By the mid-eighties artists like Sherrie Levine, Allan McCollum, Philip Taaffe, Moira Dryer, Jonathan Lasker, Shirley Kaneda, Polly Apfelbaum.... They began to interest me because their work was doing something new with abstraction. I've never been very happy with traditional expressionistic painting. The idea that the painting is a stand-in for the *self* seems wrong-headed to me.

But, on the other hand, Minimalism and much of what followed seemed too limited, too much involved with the painting as an object that could only be defined on its own terms. It was the kind of painting that told you how to look at it. It was too clear in a way. I wanted to see painting that was logical but still flexible and ambiguous. I've always thought that the answer lay in referentiality—the abstract painting's connection to the complex world of signs around it.

RPB: *What do you mean by that?*

VJ: A painting is a kind of decoding device for the culture from which it comes. We live in a world that's complicated and abstract—nothing is simple anymore. We're continually accessing different levels of image and information. This is what abstract art can do very well.

Even though I feel strongly about abstract art, that doesn't mean that I only like one sort of thing. I collect and live with a wide range of art; I see hundreds of exhibitions a year. I look at everything. It's a great pleasure.

RPB: *What are some of the other influences which surface in your work, consciously or unconsciously?*

VJ: Well, music. Playing flute and piccolo in the Greenville High School band eventually led me to Bach, jazz and Philip Glass, a big favorite of mine and an influence on my work.

I am also attracted to architecture, its theory, history and practice. In many ways I have come to understand and enjoy theoretical issues in art through music and architecture.

RPB: *Since you are established primarily as a painter, do you work in other mediums? What relationship do those works have to your paintings?*

VJ: Painting is the basis for all of my work. I use other materials and processes as nourishment, a reality check for the paintings. Printmaking has always been important. I've made etchings, screen prints, lithographs and woodcuts. Since printmaking generally involves "disassembling" the working process, you are constantly forced to rethink the structure of your work when making prints.

Also, since the mid-eighties I have completed a number of large-scale public projects using a variety of materials and in many very different situations. I designed steel fences, ceramic wall murals and stained glass windows. I also did a three and one-half acre public plaza in New York City, paved with brick and granite. In that project, the working process was much more like architecture, landscape architecture or maybe city planning. New York City's art commission gave me an award for that project.

Recently, I designed a garden in Alabama at the Birmingham Museum of Art, complete with plantings, pools and cast iron benches. I received an award for that one from the American Society of Landscape Architects. For me, that was like receiving a Nobel Prize.

My current project is a floor mosaic for the architect Cesar Pelli, which will be installed in the new Washington National Airport that he is designing. In these public projects, the existing site itself becomes the most influential factor in determining what I do. The materials I use are just other ingredients. Painting is similar for me. I see it as a cultural site, an arena in which I operate.

RPB: *In which directions do you foresee your work will go?*

VJ: Last year I started working in a very new way. Previously, I would generally begin a new body of work by taking an unfamiliar approach in the drawing stage. This time I wanted to change the actual painting process, shifting emphasis to different elements and see what would happen. By developing a new process, my whole way of thinking about painting and drawing changed. The possibilities now open to me seem so extensive—it's a whole new ball game.

RPB: *Is this evident in the current exhibition?*

VJ: I think that the last work in the exhibition both looks back to my earliest work and also moves ahead in a new direction. First of all, it is essentially monochromatic— black and gray tones—it's symmetrical and it has a strongly ornamental feel. But something else is going on, and it has a lot to do with a different working process. I think that the new paintings are quite evocative in sort of a Gothic, brooding way. The backgrounds are poured on and the surfaces are very shiny and rich. There's a kind of curtain or veil effect, which works in counterpoint to the almost knife-like crispness of the foreground figures. I've always wanted to be multi-lingual, so to speak. Abstraction, because it's not or at least shouldn't be tied down to one way of seeing, has the ability to cross boundaries—to be material and immaterial, outside itself and inside too, to be hot and cool, straightforward and elusive, familiar and also quite new. The paradox is that with each painting you are starting fresh, and yet each painting carries with it the stamp of everything that's gone before. I've been doing this work for about twenty years now and in a way it's as strange and exciting to me—and as full of possibilities—as it was when I started.

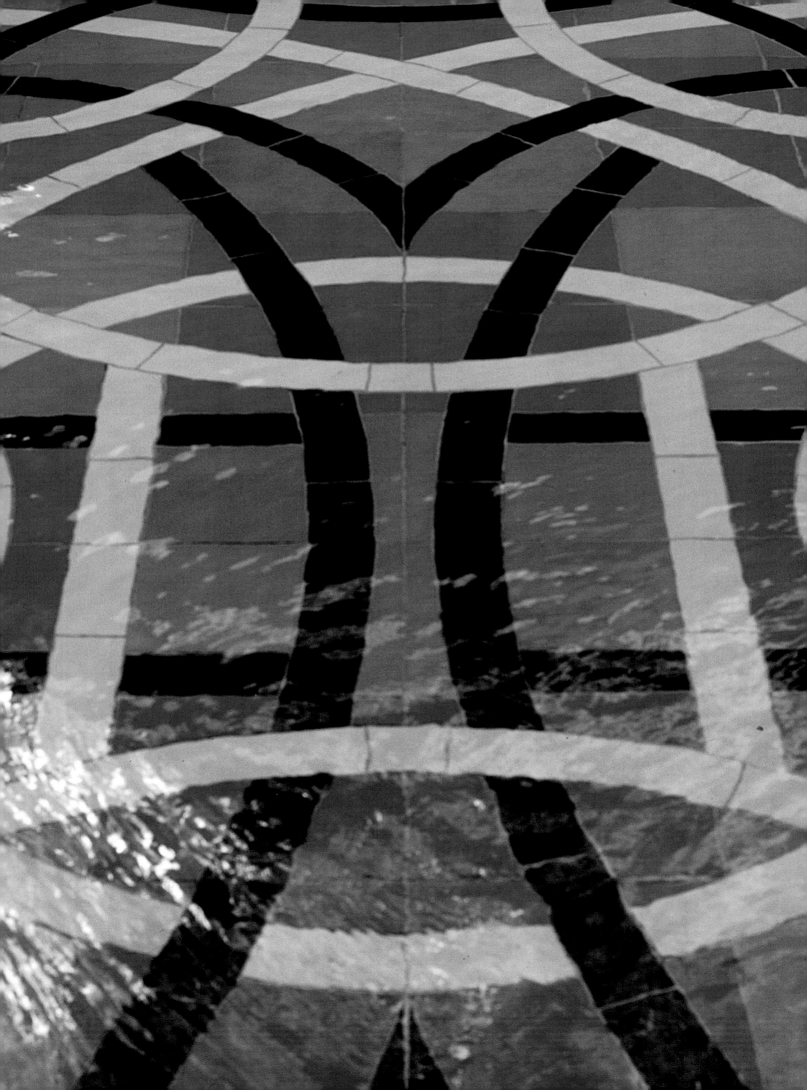

Annotated Listing of Permanent Public and Architectural Projects

by Jane Necol

As interested in cultural debate as in shaping our experience of space through her distinct mode of abstraction, Valerie Jaudon melds utility and ornament, feminist collaborative practice, and architecture in her site specific projects, sympathetically combining simply fabricated materials with their environment to narrate symbolically the sites' function. Having received a tutorial in the history and theory of architecture while working on projects for the Philadelphia firm of Mitchell/Giurgola, she applied her intuitive, orderly process of painting to real materials in real space. By going outside art, she found the same language of form and structure in abstract painting and modern architecture. This lucid approach, in its turn, equipped Jaudon to tackle the enormous demands of public commissions in a confidently visionary but non-confrontational manner that asserted that human needs and design belonged on equal footing and complemented her commitment to rethinking the relationship of art and craft.

1977

Untitled ceiling mural, oil on plaster, 90' x 22'. Philadelphia INA building, Pennsylvania; Romaldo Giurgola, architect.

Jaudon's fresco-like ceiling, painted *in situ* in an interlace of matte robin's egg blue and glossy white tinted flesh-pink, is formally related to the lobby's design of built-in geometric shapes and "lines the eye doesn't even see." Her modular drawing unfolds into a four-part painting, insinuating itself into the lobby's architectonics and altering the vast space.

1988

Long Division, *fence, painted steel, 12' x 60'. MTA Lexington Avenue and 23rd Street subway station New York, New York.*

Among the first artists commissioned to create architectural projects for New York's mass transit system, Jaudon transformed the little cavelike subway station—a space without architecture—into a knowable place. Based on patterns in her architectural paintings, a security fence was built in the MTA's requisite one-inch steel bars welded in a matrix of 2 x 2 steel posts; in the fence's lateral extension and angled corner, the symmetry of the paintings was broken open. Guided by the structural "bones" of the station, she designed the fence to divide the paid and unpaid zones of the station, bringing a logical structure as well as a psychological dimension of seeing into the unknown to the space. Permeable by the eye, the fence functions as a "transparent lens through which the people can see where they are going and where they have been."

Detail of Blue Pools Courtyard *(left). Birmingham Museum of Art, Alabama.*

1988

Untitled fence,
wrought iron, 10' x 21'.
Philadelphia Planned Parenthood
Headquarters, Pennsylvania;
George Yu, architect.

Contextually part of the historic site through its size and method of fabrication, the fence, located along the building's discreet side entrance, is delicately proportioned to the scale of the 19th century row house, forming a secure but airy gateway between public and private space through which a small garden is visible. Hand-forged of one-half inch iron bars, the modular sections in Jaudon's signature curvilinear patterns were wrought into sculptural form by traditional blacksmithing.

1988-1989

Pilot, wall mural,
oil on canvas, 8' x 16'.
Atlanta City Hall, Georgia.

Satisfying the artist's desire to make a large, architecturally-scaled work, this double-square painting in three shades of cadmium red, essentially the next work after *Constant* (page 64), was created at long distance, information about the lobby space learned from the architect's drawings.

1989

Freestyle, wall mural,
ceramic tile, 12' x 72'.
Equitable building, New York,
New York.

Luxurious but simple, the pool-sized mural is perfectly suited to its site—the pool room of a private health club designed by Edward Larrabee Barnes—in its architecturally-referenced design and maintenance-free material. Mirroring the pool from the wall, the mural is composed of custom-made ceramic tiles cut to fit the design in cool blue, turquoise, black and white, reflecting not only the color harmonies of Moorish ornamental art but also the colors of the water and details of the pool. The animated horizontal composition of diagonal lines, arcs and circles in "dashes" of black and white over a gridded field of blue and turquoise, builds on the spare linearity of the space, whose crossed diagonals of the cove ceiling and the curve of the archway are repeated across the mural, creating a swinging rhythm that keeps time with the strokes of a swimmer cutting through water. An aqueous light suffuses the space, magically the palest green, like the lapping water and the hazy translucency serendipitously acquired by the turquoise tiles during firing..

1989

Untitled windows, stained glass, 7' x 24'. Private residence, Malibu, California.

Skied at clerestory level in a two-storied room facing the Pacific Ocean, the three round-arched windows were fashioned of leaded glass with the techniques used to create the stained glass windows of medieval cathedrals. The thick ribbon interlace of white on a blue field is translucent enough to glimpse a bird's silhouette yet mysteriously opaque, the blue the very color of the sky on a cloudless day, and the faintly pinkish white equal in brightness to pure light on an overcast day at the beach.

1989

Reunion, paving plan, brick and granite with inlaid granite floor, 3.5 acres, 34' diameter, respectively. Police Plaza/Municipal Building, New York, New York.

Inspired by the area's palimpsest of historical architecture, Jaudon has worked to bring enduring order to the sprawling 3.5 acre urban space bounded by the venerable Municipal Building (designed by McKim, Mead and White) and Police Plaza. By subtly organizing the spatial and architectural environment through her unobtrusive design of sturdy brick pavements spread like geometric blankets of rectilinear patterns in pink, dark red and dark gray brick over the multi-leveled area to demark eight plazas and emphasize the axial vista west to the Hudson River down the central promenade, she offers a measured dignity to the pedestrian navigating the eccentrically-shaped terrain. Drawing the visual field together is a 34' wide medallion in an interlace of red, white and black granite set into the bricks at the arched entrance to the Municipal Building, its diameter and scale of design corresponding to the archway's coffered barrel vault. Overall, in spite of delays inevitable in public commissions of this scope and politicization, Jaudon's considered design for the needs of 20,000 human beings who stream through the area daily is a triumph of feminist collaborative practice.

1991

Eastern Standard, wall mural, oil on canvas, 16' x 13'. 1675 Broadway, New York, New York.

The mural-like painting, visible from the street, summons one's gaze while structuring and warming the tenebrous lobby paneled in green granite through the artist's eloquent use of three intense cadmium reds, the one synthetic paint adding a neon zest to the already saturated color. Her largest painting, its dynamic composition is similar to smaller works of the same date (*Azimuth*, page 67).

1993

Blue Pools Courtyard, *garden, pool and bench design, plantings, bluestone, brick, tile, cast iron, 70' x 80'. Birmingham Museum of Art, Alabama; Edward Larrabee Barnes, architect.*

Jaudon has fused knowledge of art, architecture and landscape architecture with a gift for social discourse to create a garden of delights. Like Persian carpets, the shield-shaped and rectilinear-shaped pavements of locally mold-made red bricks and blue-stone accents, spreading out from the glass-walled museum beneath a grove of oak trees, frame a physical and visual field to wander through. Set into the longitudinal axis are two rectangular reflecting pools, lined in ceramic tile in black, white, blue and turquoise curvilinear patterns, each geometric shape set to fit in opus sectile, the technique used by Jaudon in all her tile projects. The water's movement in the shallow pools was precisely calibrated so that the drawings are clearly visible from above. Adding an organic variable to the fabricated precision of the pavings and pools are the surrounding plantings that flower white in season which Jaudon selected in collabora-tion with local horticulturists. Modular cast iron park benches made locally in the disappearing art of sand casting invite *tête-à-têtes*. It is apparent that Jaudon's upbring-ing in the Deep South instantly reconnected her with native interests to create an oasis where geometric order converses with everchanging nature, stimulating and reposing human response.

1994

Refraction, *wall mural, ceramic tile, 15' x 15'. Laboratory Science Building, Staten Island College, New York; Mitchell/Giurgola Architects.*

Fitted within the functional lines of a glass-walled stairwell, the square mural, designed like a painting in a checkerboard pattern of alternating white and colored blocks arranged in a color progression based on the spectrum (*Social Contract*, page 68), is made of vitreous glazed square tiles and smaller pieces laser-cut to fit the shape of the sharply-contoured overlaid black geometric figures. Natural light plays over the grid, breaking up the geometry and emphasizing the source of all color. Jaudon's figural chains sway over the field hardly begging the question, as if aesthetic distinctions must still be made between decorative art and fine art.

Selected Exhibitions

Valerie Jaudon Born August 6, 1945, Greenville, Mississippi

Lives and works in New York and East Hampton, New York

Education

1963-1965	Mississippi University for Women, Columbus, Mississippi
1965	Memphis Academy of Art, Memphis, Tennessee
1966-1967	University of the Americas, Mexico City, Mexico
1968-1969	St. Martin's School of Art, London, England

Solo Exhibitions

1977	Holly Solomon Gallery, New York, New York
	Pennsylvania Academy of the Fine Arts, Philadelphia
1978	Holly Solomon Gallery, New York, New York
1979	Galerie Bischofberger, Zurich, Switzerland
	Holly Solomon Gallery, New York, New York
1980	Galerie Hans Strelow, Dusseldorf, Germany
1981	Corcoran Gallery, Los Angeles, California
	Holly Solomon Gallery, New York, New York
1983	Sidney Janis Gallery, New York, New York
	Quadrat Museum, Bottrop, Germany
	Amerika Haus, Berlin, Germany
	Dart Gallery, Chicago, Illinois
1985	Sidney Janis Gallery, New York, New York
	Fay Gold Gallery, Atlanta, Georgia
	McIntosh/Drysdale Gallery, Washington, D.C.
1986	Sidney Janis Gallery, New York, New York
1988	Sidney Janis Gallery, New York, New York
1990	Sidney Janis Gallery, New York, New York
1993	Sidney Janis Gallery, New York, New York
1994	The Barbara Scott Gallery, Bay Harbor Islands, Florida

1969 St. Martin's School of Art, London, England

1973 University of Missouri, St. Louis

1975 "Sonia Delaunay-Valerie Jaudon," Livingston-Learmonth Gallery, New York, New York

Casa Thomas Jefferson, Brasilia, Brazil

The Aldrich Museum of Contemporary Art, Ridgefield, Connecticut

"76 Jefferson Street," The Museum of Modern Art, New York, New York

1976 Albright-Knox Art Gallery, Buffalo, New York

"Summer Group Show," Holly Solomon Gallery, New York, New York

"Ten Approaches to the Decorative," Allesandra Gallery, New York, New York

1977 "Painting 1975-1977," Sarah Lawrence College, Bronxville, New York

"Selections 1977," The Aldrich Museum of Contemporary Art, Ridgefield, Connecticut

"Recent Acquisitions," Hirshhorn Museum and Sculpture Garden, Smithsonian Institution, Washington, D.C.

"Pattern Painting," P.S. 1, Long Island City, New York

"Patterning & Decoration," The Museum of the American Foundation for the Arts, Miami, Florida

"Painting 1975, 1976, 1977," The Contemporary Art Center, Cincinnati, Ohio

"Critic's Choice 1976 - 1977," Joe & Emily Lowe Art Gallery, Syracuse, New York, and Munson-Williams-Proctor Institute Museum of Art, Utica, New York

"Patterning & Decoration," Galerie Alexandra Monett, Brussels, Belgium

1978 "In the Realm of the Monochromatic," Susan Caldwell Gallery, New York, New York

"Amerikanska Bilder," Galerie Leger, Malmo, Sweden

"Art for Future Collectors," Holly Solomon Gallery, New York, New York

"Pattern on Paper," Gladstone/Villani Gallery, New York, New York

"Gold and Silver," Holly Solomon Gallery, New York, New York

"Black and White on Paper," Nobe Gallery, New York, New York

"Pattern and Decoration," Sewall Art Gallery, Rice University, Houston, Texas

"Decorative Art: Recent Work," Douglas College Art Gallery, Rutgers University, New Brunswick, New Jersey

1979 "Black and White Are Colors: Paintings of the 1950's-1970's," Lang Art Gallery, Claremont College, California

"Patterns Plus," Dayton Art Institute, Ohio

"Patterning Painting," Palais des Beaux-Arts, Brussels, Belgium

"Small is Beautiful," Freedman Gallery, Albright College, Reading, Pennsylvania (traveled)

"Patterning and Decoration on Paper," Galerie Habermann, Cologne, Germany

"Young Americans of the Eighties," Galerie Hans Strelow, Dusseldorf, Germany

"Pattern Painting/Decoration Art," Galerie Krinzinger, Innsbruck, Austria (traveled)

1980 "Dekor," Mannheimer Kunstverein, Mannheim, Germany (traveled)

"Les Nouveaux Fauves-Die Neuen Wilden," Neue Galerie, Sammlung-Ludwig, Aachen, Germany

"New York Pattern Show," Merwin Gallery, Illinois Wesleyan University, Bloomington, Indiana

"Seven Young Americans," Sidney Janis Gallery, New York, New York

"The Morton G. Neumann Family Collection," National Gallery of Art, Smithsonian
 Institution, Washington, D.C. (traveled)

"Islamic Allusions," Alternative Museum, New York, New York

"Secular-Rituals-Sacred," St. Peter's Church, New York, New York

"Decoration," San Francisco Art Institute, California

"Prints," The Museum of Modern Art, New York, New York

"Drawings," Leo Castelli Gallery, New York, New York

"Black and White," Thomas Segal Gallery, Boston, Massachusetts

"Open 80," Venice Biennale, Venice, Italy

1981 "CAPS 1980-81," Herbert F. Johnson Museum of Art, Cornell University, Ithaca, New York

"Out of New York," Root Art Center, Hamilton College, Clinton, New York

"New Directions," Sidney Janis Gallery, New York, New York (traveled)

"The Decorative Image," McIntosh/Drysdale Gallery, Washington, D. C.

"The Pattern Principle," Ohio University, Lancaster

Indiana University Art Gallery, Bloomington

"Art for ERA," Zabriskie Gallery, New York, New York

"U.S. Art Now: Aktuella tendenser i amerikansk konst," Nordiska Komaniet, Stockholm,
 Sweden (traveled)

"Aspects of Post-Modernism: Decorative and Narrative Art," Squibb Gallery,
 Princeton, New Jersey

"Pattern Painting," South Hill Park Arts Centre, Bracknell, Berkshire, England

1982 "A Look Back—A Look Forward," The Aldrich Museum of Contemporary Art, Ridgefield,
 Connecticut

"Gallery Group Show," Holly Solomon Gallery, New York, New York

"Aspects of Post-Modernism," Fay Gold Gallery, Atlanta, Georgia

"A Private Vision: Contemporary Art from the Graham Gund Collection," Museum of
 Fine Arts, Boston, Massachusetts

"The Spirit of Orientalism," Neuberger Museum, State University of New York at Purchase

1983 "The Rothschild Bank of Zurich Collection," La Jolla Museum, California

"New Image/Pattern & Decoration," Kalamazoo Institute of Arts, Michigan
 (traveled)

"New Work," Sidney Janis Gallery, New York, New York

"Ornamentalism," The Hudson River Museum of Westchester, Yonkers,
 New York (traveled)

"New Decorative Art," The Berkshire Museum, Pittsfield, Massachusetts

"On the Leading Edge—Cross Currents in Contemporary Art of the
 Eighties," The General Electric Corporate Art Collection, Fairfield,
 Connecticut

"American Art at Ryhave," American Embassy, Copenhagen, Denmark

"Art Today," Ward Gallery, Rochester, New York

"Art Historical Overview," Holly Solomon Gallery, New York, New York

1984 "50 Artists/50 States," Fuller Goldeen Gallery, San Francisco, California

"Arabesque: Grand Gestures in Painting, Sculpture, and Decorative
 Arts," Bette Stoller Gallery, New York, New York

"The Decorative Continues," Pam Adler Gallery, New York, New York

"American Women Artists—Part II: The Recent Generation," Sidney Janis Gallery,
 New York, New York

"1 + 1 = 2," Bernice Steinbaum Gallery, New York, New York (traveled)

"Eccentric Images," Margo Leavin Gallery, Los Angeles, California

"Abstract Painting Redefined," Louis Meisel Gallery, New York, New York (traveled)

1985 "Geometric Abstractions: Selections from a Decade, 1975-1985," The Bronx Museum of the Arts, New York

"Celebration 1977-1985," McIntosh/Drysdale Gallery, Washington, D.C.

Women Artists Exhibition, The Palladium, New York, New York

"This Way/That Way," Thorpe Intermedia Gallery, Sparkill, New York

"American Art: American Women," Stamford Museum, Connecticut

Creative Time Benefit, Christie's, New York, New York

1986 "Art from the City University of New York: Approaches to Abstraction," Shanghai Exhibition Center, China

Poetry Project Benefit and Auction, St. Mark's Church, New York, New York

"National Women Artists," Lee Gallery, College of Architecture, Clemson University, South Carolina

"Happy Happy," Phyllis Kind Gallery, New York, New York

"Frederick Weismann Collection," Gulbenkian Foundation, Lisbon, Portugal (traveled)

1987 "New Acquisitions," Dayton Art Institute, Ohio

"Art Against AIDS," Phyllis Kind Gallery, New York, New York

"Friends of L.T.D.," Paris Kent Gallery, Kent, Connecticut

Group Exhibition, Gallery International 52, New York, New York

"Generations of Geometry," Whitney Museum of American Art at Equitable Center, New York, New York

"Gold," Maloney Gallery, Santa Monica, California

1988 "Systems and Abstraction," Leubsdorf Art Gallery, Hunter College, New York, New York

"Projects and Proposals," City Gallery, Department of Cultural Affairs, New York, New York

1989 "Painting: Between Awareness and Desire," Cyrus Gallery, New York, New York

"Painting Between Paradigms: Between the Sacred and the Profane," Galerie Rhamel, Cologne, Germany

"Making Their Mark," Cincinnati Art Museum, Ohio (traveled)

1990 "Concept-Decoratif, Anti-Formalist Art of the '70's," Nahan Contemporary, New York, New York

"White Columns Twentieth Anniversary Benefit Exhibition," White Columns, New York, New York

"Grids," Vrej Baghoomian Gallery, New York, New York

1991 "Who Framed Modern Art or the Quantitative Life of Roger Rabbit," Sidney Janis Gallery, New York, New York

"Poets/Painters Collaborations," Brooke Alexander Editions, New York, New York

"Masterworks of Contemporary Sculpture, Painting and Drawing: The 1930's to the 1990's," Bellas Artes, Santa Fe, New Mexico

"Geometric Perspectives," Pfizer, Inc., New York, New York

"Conceptual Abstraction," Sidney Janis Gallery, New York, New York

1992 "Shades of Difference (The Feminine in Abstract Painting)," Sandra Gering Gallery, New York, New York

"American Figuration," Henie-Onstad Art Centre, Hovikodden, Norway

1993 MFA Faculty Artists' Exhibition, Hunter College Art Gallery, New York, New York

"Rewriting History: The Salon of 1993," Montgomery Glasoe Fine Art, Minneapolis, Minnesota

"An American Homage to Matisse," Sidney Janis Gallery, New York, New York

"Jours Tranquilles & Clichy," 40 Rue de Rochechouart, Paris, France (traveled)

"New Abstraction," Betsy Senior Gallery, New York, New York

BOMB Magazine Benefit, Fawbush Gallery, New York, New York

"Italy-America, Abstraction Redefined," The National Gallery of Modern Art of the Republic of San Marino, Italy

"Studio to Site: Public Art in New York City," Sidney Mishkin Gallery/Baruch College, New York, New York

1994 "Art in Route," Paine Weber Art Gallery, New York, New York, and The Museums at Stony Brook, New York

"American Abstraction: A New Decade," Southern Alleghenies Museum of Art, Loretto, Pennsylvania

1995 "Reconstructivism, New Geometric Painting in New York," Space 504, New York, New York

"Re: Fab-Painting Abstracted, Fabricated, and Revised," Contemporary Art Museum, University of South Florida, Tampa (traveled)

Selected Collections

Albright-Knox Art Gallery, Buffalo, New York

The Aldrich Museum of Contemporary Art, Ridgefield, Connecticut

Birmingham Museum of Art, Alabama

Dayton Art Institute, Ohio

Fogg Art Museum, Harvard University, Cambridge, Massachusetts

Greenville County Museum of Art, South Carolina

Hirshhorn Museum and Sculpture Garden, Smithsonian Institution, Washington, D.C.

Indiana University Art Museum, Bloomington

The Frances Lehman Loeb Art Center, Vassar College, Poughkeepsie, New York

Louisiana Museum, Humlebaek, Denmark

The Museum of Modern Art, New York, New York

National Museum of Women in the Arts, Washington, D.C.

Saint Louis Art Museum, Missouri

Sammlung-Ludwig Museum, Aachen, Germany

Jane Voorhees Zimmerli Art Museum, Rutgers University, New Brunswick, New Jersey

Selected Bibliography

1975 Bourdon, David. "The 76 Jefferson Streeters Show Up at MOMA," *The Village Voice*, September 22.

Frank, Peter. "New York Reviews," *Artnews*, Summer.

1976 Perrone, Jeff. "Approaching the Decorative," *Artforum*, December.

1977 Brown, Ellen. " 'Painting 75/76/77' at CAC Is a Must to See," *The Cincinnati Post*, August 13.

Goldin, Amy. "Patterning & Decoration," The Museum of the American Foundation for the Arts, Miami, Florida (exhibition catalog).

Keating, Douglas J. "Design for Ceiling Has Her Up in the Air—About 35 Feet Up," *Philadelphia Inquirer*, August 24.

Perreault, John. "More Patterns...: Valerie Jaudon at Holly Solomon," *Soho Weekly News*, May 5.

_____ . "Issues in Pattern Painting," *Artforum*, November.

Perrone, Jeff. "Review," *Artforum*, September.

Webster, Sally. "Spacial Geometry, Art in Architecture," *Arts Exchange*, November/December.

1978 Anderson, Alexandra. "Voice Choices," *The Village Voice*, July 10.

_____ . "Voice Choices," *The Village Voice*, October 23.

Frank, Peter. "Paint Misbehavin'," *The Village Voice*, October 16.

Goldin, Amy. "The Body Language of Pictures," *Artforum*, March.

Moser, Charlotte. " 'Pattern' Show a Top Exhibition of the Season," *Houston Chronicle*, November 3.

Olejarz, Harold. "Valerie Jaudon," *Arts*, December.

Perreault, John. "Season's Greetings," *Soho Weekly News*, September 28.

Rickey, Carrie. "Pattern Painting," *Arts Magazine*, January.

Senie, Harriet. "Geometric Art Shines," *New York Post*, November 20.

1979 Bongard, Dr. Willi. "Pattern Painting," *Archetekture & Wohnen*, February.

_____ . "Sammler der ersten Stunde Machten doppeltes Geld," *Welt Kunstmarkt*, September.

Boudaille, Georges. "Pattern Painting," *Connaissance des Arts*, September.

Dobson, Rona. "Brussels: Patterning Painting," *International Herald Tribune*, February 10.

Meister, Von Helga. "Junge Kunst aus den USA," *Dusseldorfer Machrichten*, December 13.

Perreault, John. "The New Decorativeness," *Portfolio*, June/July.

_____ . "Patterning," *Patterning Painting*, Palais des Beaux-Arts, Brussels, Belgium (exhibition catalog).

_____ . "Pattern-eine Einfuhrung," *Du, The Art Magazine*, June.

Rickey, Carrie. "Decoration, Ornament, Pattern and Utility: Four Tendencies in Search of a Movement," *Flash Art*, June/July.

_____. "Review," *Artforum*, January.

_____. "Voice Choices," *The Village Voice*, October 15.

Rubin, David S. "Black and White Are Colors: Paintings of the 1950's–1970's," Lang Art Gallery, Claremont College, California (exhibition catalog).

Schipper, Merle. "Black and White Are Colors," *Arts Magazine*, June.

Strickler, Madeline, and Dominik Keller. "Atelierbesuche," *Du, The Art Magazine*, June.

Strohl, Audrey. "Mississippi-Born Painter Finds Success with Geometric Art," *Memphis Press-Scimitar*, January 4.

Szeemann, Harald. "Decorative Art Today," *Du, The Art Magazine*, June.

_____. "Zuruck und hin zur «Wurde des Dekorativen»," *Du, The Art Magazine*, June.

Yau, John. "Review: Valerie Jaudon at Holly Solomon," *Art in America*, May.

1980 Albright, Thomas. "No Matter What It's Called, It's Decorative," *Datebook*, October 21.

Atkins, Robert. "Decorative Inclinations," *Bay Guardian*, October.

Auffermann, Verena. "Diebstahl ohne Reue," *Rhein-Neckar-Zeitung*, January 19/20.

Bourdon, David. "Art," *Vogue*, November.

Brody, Jacqueline. "Prints," *Print Collector's Newsletter*, July/August.

Carmean, E.A., Jr. "American Abstraction and Decorative Painting," *The Morton G. Neumann Family Collection*, National Gallery of Art, Smithsonian Institution, Washington, D.C. (exhibition catalog).

Frank, Peter. "What's Happening in Contemporary Art," *Diversion*, April.

Giessler, Ursula. "Amerikas Muster-Maler," *Saarbrucker Zeitung*, February 4.

Glueck, Grace. "Women Artists '80," *Artnews*, October.

Godfrey, Tony. "Dekor: The Marriage of Reason and Squalor (?!)," *Art Monthly*, April.

Gosling, Nigel. "Pop Goes Decoration," *The Observer*, May 4.

Haley, Michael. "Pattern Painting: New Art for a New Decade," *Sky*, July.

Hartmann, Horst. "Pattern Art in Mannheimer Kunstverein," *Darmstadter Echo*, January 19.

Hegewisch, Katharina. "Hermann Hesse Geist der Duft der Raucherstabchen," *Frankfurter Allegemeine Zeitung*, February 4.

Herchenroder, Christian. "Aus den Galerien," *Handelsblatt*, March 29.

_____. "Aus den Galerien," *Amtliche Bekanntmachungen*, January 15.

Januszczak, Waldemar. "The Diligent Search for Spontaneous Bad Taste," *Arts Guardian*, May 6.

Kingsley, April. "Introduction," *Islamic Allusions*, Alternative Museum, New York, New York (exhibition catalog).

Kramer, Hilton. "Art: Seven Young Americans," *The New York Times*, April 18.

Kramer-Badoni, Rudolf. "Kein Adel fur den Kitsch" *Die Welt*, January.

Kunz, Martin. "The Development of Physical Action into a Psychic Intensity of the Picture," *Flash Art*, June.

Kupper, Anne. "Die Neuen Wilden," *Baukultur Kunst*, April.

Larson, Kay. "For the First Time Women are Leading...Not Following," *Artnews*, October.

_____. "Space Walk," *The Village Voice*, April 28.

Larson, Kay, and Rickey, Carrie. "In Critical Condition: A Double Take on Clement Greenberg," *The Village Voice,* April 21.

Loercher, Diana. "When Is It Art? When Is It Crafts?," *Christian Science Monitor,* no date.

Marx, Heike. "Kunst in der Nahe von Kitsch," *Die Rheinpfalz,* January 16.

Radice, Barbara. "Superfici, equipotenziali, piacevoli, dipinte," *Modo,* September.

Rice, Nancy N. "Pattern and Decoration," *The New Art Examiner,* March.

Rickey, Carrie. "Decor and Ornamentation—An Introduction," *Dekor,* Mannheimer Kunstverein, Mannheim, Germany (exhibition catalog).

Schwarze, Dirk. "Ornament und Farbe," *Rheinischea Post,* April 15.

_____. "Die wilden und die Dekorativen," *Rheinischea Post,* February 2.

_____. "Unbefangene Kunst," *Rheinischea Post,* January 5.

Trini, di Tommaso. "Cronaca Dell'Arte a New York," *Domus,* January.

Wotzel, Beitrag. "Dekor," *Studio Karlsruhe Kulturreport,* January.

Wykes-Joyce, Max. "Americans in London," *The International Herald Tribune,* May 3-4.

Yee, Roger. "A New Urban Center for Harrisburg," *Architectural Record,* December.

1981 Alinovi, Francesca. "Quel che piace a me, Dedicato al Post-Moderno," *Flash Art,* Summer.

"Aspects of Post-Modernism: Decorative and Narrative Art," Squibb Gallery, Princeton, New Jersey (exhibition catalog).

Bright, Martin. "Pattern Painting: Introduction," South Hill Park Arts Centre, Bracknell, Berkshire, England (exhibition catalog).

Gaugh, Harry F. "Pattern Painting and New Image Art," *New Directions* (exhibition catalog).

Glueck, Grace. "Reviews," *The New York Times,* May 1.

Hall, Jacqueline. "Visual Pleasure, without a Message, Aim of Impressive Show in Lancaster," *Columbus Ohio Dispatch,* September.

Hunter, Sam. "Introduction," *New Directions* (exhibition catalog).

Levin, Kim. "Art," *The Village Voice,* April 29.

Mallinson, Constance. "Valerie Jaudon at James Corcoran," *Images and Issues,* Summer.

McCue, George. "Spirit from St. Louis," *Progressive Architecture,* November.

Meyer, Ruth K. *The Pattern Principle,* Ohio University, Lancaster (exhibition catalog).

Morgan, Robert C. "Abstract Painting: The New Pictorialism," *New Directions* (exhibition catalog).

Perreault, John. "Mideast Pipeline," *Soho Weekly News,* January 14.

Phillips, Deborah C. "Reviews," *Artnews,* November.

Wilson, Judith. "Immigrating Ideas," *The Village Voice,* April 22.

Wilson, William. "The Galleries: La Cienega Area," *The Los Angeles Times,* January 23.

1982 Brody, Jacqueline. "Reviews," *Print Collector's Newsletter,* May.

Carboni, Massimo. "Valerie Jaudon," *Contemporary Artists.*

Glenn, Constance W. "The Collectors: Stage for Contemporary Art," *Architectural Digest,* December.

Hunter, Sam. "Post-Modern Painting," *Portfolio,* January/February.

Jensen, Robert, and Patricia Conway. *Ornamentalism: The New Decorativeness in Architecture & Design.*

Oliva, Achille Bonito. *Trans Avant-Garde International.*

Phillips, Deborah C. "New Editions," *Artnews*, September.

Tomkins, Calvin. "The Art World: Tatyana Grosman," *The New Yorker*, August 9.

1983 Armstrong, Richard. "Reviews," *Artforum*, September.

"Geometrische Formen," *Ruhr-Nachrichten, Bottroper Volkszeitung*, February 5.

Glueck, Grace. "Reviews," *The New York Times*, April 22.

Hunter, Sam. *New Image/Pattern & Decoration*, Kalamazoo Institute of Arts, Michigan (exhibition catalog).

_____. *Valerie Jaudon*, Quadrat Museum, Bottrop, Germany, and Amerika Haus, Berlin, Germany (exhibition catalogs).

Larson, Kay. "Freezing Expressionism," *New York Magazine*, April 25.

Levin, Kim. "Voice Centerfold," *The Village Voice*, April 20.

Loskill, Hans-Jorg. "Flache und Ornament," *Westdeutsche Allgemeine*, February 16.

Lugo, Mark. "Valerie Jaudon: An Exhibition of Recent Paintings," *The San Diego Tribune*, April 29.

"Moderne Kunst wirkt international," *Ruhr-Nachrichten, Bottroper Volkszeitung*, February 7.

" 'Neue Meister' aus den USA," *Volksblatt Berlin*, September 28.

Perreault, John. "Allusive Depths: Valerie Jaudon," *Art in America*, October.

Raynor, Vivien. "The Revival of 'Ornamentalism'," *The New York Times*, April 3.

"Refined Plaiting for the Tricentennial at Amerika Haus," *Die Morgenpost*, October 20.

Schmidt, Konrad. "Ausstellung in Bottrop: Gemalde wie Teppiche—Plastiken wie Schriftzeichen," *Ruhr-Nachrichten, Bottroper Volkszeitung*, February 16.

Traulsen, Jane. "Jensen's 'Ornamentalism': The Flip Side of Hi-Tech," *Reporter Dispatch*, May 1.

Westfall, Stephen. "Reviews," *Arts Magazine*, September 28.

Wulffen, Thomas. "The Decorative Juncture—'New Masters' at the Amerika Haus Berlin," *Der Tagesspiegel*, October 5.

1985 Gill, Susan. "New York Reviews," *Artnews*, September.

Glueck, Grace. "Art: Abstract Painters Regain Old Charisma," *The New York Times*, March 8.

Hertz, Richard. *Theories of Contemporary Art.*

Hughes, Robert. "Art: Careerism and Hype Amidst the Image Haze," *Time*, June 17.

Raynor, Vivien. "Reviews," *The New York Times*, April 26.

_____ . "Two Shows Are Merged, with Little in Common," *The New York Times*, November 10.

Sandback, Amy Baker, ed. *Looking Critically: 21 Years of Artforum Magazine.*

Westfall, Stephen. "Reviews," *Arts*, December.

1986 Arnason, H.H. "The Pluralistic Seventies: From the New Illusionism to Pattern, Decoration, and New Image Art," *History of Modern Art.*

Larson, Kay. "Reviews," *New York Magazine*, December 1.

Ratcliff, Carter. "Abstract Painting and the Idea of Modernity," *Abstract Painting Redefined*, The Fine Arts Center Art Gallery, State University of New York at Stony Brook (exhibition catalog).

Robins, Corrine. *The Pluralist Era.*

1987 Brach, Paul. "Valerie Jaudon's Art Talk," *The East Hampton Star*, August 13.

Diehl, Carol. "Double or Nothing," *Art and Antiques*, February.

Sarje, Kimmo. "Abstraction and Reflection: Recent Geometric Painting,'' *Generations of Geometry*, Whitney Museum of American Art at Equitable Center, New York, New York (exhibition catalog).

Slivka, Rose C.S. "From the Studio," *The East Hampton Star*, March 12.

1988 Dixon, Jenny. "Public Domain," *American Craft*, June/July.

Seggerman, Helen Louise. "Sidney Janis Gallery," *Tableau Fine Arts*, April.

Tomkins, Calvin. *Post to Neo—The Art World of the '80's.*

1989 Alexander, Max. "Art in the Underground," *Art in America*, December.

Calnek, Anthony. "New York," *Contemporanea*, June.

Cobb, James C. "The South's South: The Enigma of Creativity in the Mississippi Delta," *The Southern Review*, Winter.

Currimbhoy, Nayana. "Offbeat and Upbeat," *Interiors*, October.

Feuer, Wendy. "Public Art from a Public Sector Perspective," *Art in the Public Interest*.

Malone, Maggie. "The Great Outdoors," *Newsweek*, October 23.

"Manhattan Municipal Building, 1914-1989, 75th Anniversary," Department of General Services, New York, New York (exhibition catalog).

Miles, Malcolm. "Speakeasy," *New Art Examiner*, Summer.

Rosen, Randy. *Making Their Mark: Women Artists Move into the Mainstream, 1970-1985.*

Sansegundo, Sheridan. "At the Galleries," *The East Hampton Star*, December 14.

Stein, Judith, and Ann-Sargent Wooster. "Making Their Mark," *Making Their Mark: Women Artists Move into the Mainstream, 1970-1985.*

Stephens, Suzanne. "Currents: When Pools Have Style, Who Needs the Beach?," *The New York Times*, June 15.

Tomkins, Calvin. "Righting the Balance," *Making Their Mark: Women Artists Move into the Mainstream, 1970-1985.*

1990 Chadwick, Whitney. *Women, Art and Society.*

Frank, Peter. "Reconstructivist Painting, Neo-Modern Abstraction in the United States," *Artspace*, April.

_____ . "Rekonstruktivismus-Neomoderne Abstraktion in den Vereinigten Staaten," *Kunstforum*, January.

Kontova, Helena, and Giancarlo Politi, ed. *Flash Art: Two Decades of History. XXI Years.*

"Letter from America," *Mizue*, Summer.

LeVine, Joan. "A Granite Reunion in a Municipal Maze," *Stoneworld*, April.

Mahoney, Robert. "Valerie Jaudon," *Flash Art*, Summer.

Malone, Maggie. "Public Art and Galleries," *New York Woman*, May.

Morgan, Robert C. "Concept-Decoratif, Anti-Formalist Art of the '70's," Nahan Contemporary, New York, New York (exhibition catalog).

"Percent-for-Art Projects in Manhattan," *The New York Observer*, October 1.

Slivka, Rose C.S. "From the Studio," *The East Hampton Star*, April 5.

1991 Antonelli, Paola. "Public Art E Manhattan," *Domus*, January.

Faust, Gretchen. "New York in Review: Valerie Jaudon," *Arts Magazine*, November.

Kaneda, Shirley. "Painting and Its Others: In the Realm of the Feminine," *Arts Magazine*, Summer.

Larson, Kay. "Art," *New York Magazine*, December 2.

_____ . "Conceptual Abstraction," *The Village Voice*, November 26.

Wepman, Dennis. "This Art's Guaranteed to Move You," *The Daily News*, January 3.

Wheeler, Daniel. *Art Since Mid Century: 1945 to the Present.*

1992 Carrier, David. "Afterlight: Exhibiting Abstract Painting in the Era of Its Belatedness," *Arts Magazine*, March.

Jaudon, Valerie. "Figuring Abstraction," *Tema Celeste*, January-March.

_____ . "Rappresentare l'astrazione," *Tema Celeste*, April.

Kaneda, Shirley. "Valerie Jaudon," *Bomb*, Winter.

Paparoni, Demetrio. "Valerie Jaudon," *Tema Celeste*, Summer.

"The Question of Gender in Art (42 Artists Respond: Does Gender Make a Difference in Contemporary Art?)," *Tema Celeste*, Autumn.

Welish, Marjorie. "Abstraction, Advocacy of," *Tema Celeste*, January-March.

1993 Fox, Catherine. "Renaissance in Birmingham," *The Atlanta Journal*, October.

Huntoon, Siri. "Valerie Jaudon," *Artnews*, May.

Johnson, Ken. "Valerie Jaudon," *Art in America*, May.

Kaimann, Frederick. "A Building Transformed," *The Birmingham News*, September.

Kemp, Kathy. "Features," *Birmingham Post-Herald*, August 27.

Machaver, Claire. "Art Review," *The Clinton Chronicle*, January 22.

Olson, Barbara and Eric. "Art's New Face," *Birmingham*, October.

Paparoni, Demetrio. "The Self-Regulation of the System," "Valerie Jaudon," *Italy-America, Abstraction Redefined* (exhibition catalog).

Welish, Marjorie. "Valerie Jaudon," *Tema Celeste*, Winter.

1994 Adams, Laurie Schneider. *A History of Western Art.*

Broude, Norma, and Mary Garrard. *The Power of Feminist Art.*

Karlins, N.F. "Pictures from the Underground: Bringing Public Art into the Cool Light of Day," *Chelsea Clinton News*, July 28.

Morris, Philip. "A Grand Opening," *Southern Accents*, September/October.

"Playing in the Neighborhood: A Stationary Glimpse of Art on the Move," *The New York Times*, July 10.

Pozzi, Lucio. "Anche la griglia della metropolitana puo essere fatta ad arte, se si e privi di pregiudizi," *Il Giornale Dell'arte*, February.

Umbanhowar, Elizabeth. "Limelight," *Echo Imprint*, Spring.

1995 Guilivi, Ariella. "Passagio a Oriente," *Tema Celeste*, March.

Melrod, George. "Post Pop Pizzazz," *Art and Antiques*, November.

Ostrow, Saul. "More Parts to the Whole: Abstract Painting After Modernism," *Art Press*, November.

Taylor, Brandon. *Avant Garde and After, Rethinking Art Now.*

Exhibition Checklist

All dimensions given in inches; height precedes width.

Bay St. Louis, 1973
acrylic on canvas
72 x 72
Collection of the artist

Bay St. Louis, 1973
colored pencil on paper
12 x 12
Collection of the artist

Mendenhall, 1973
colored pencil on paper
12 x 12
Collection of the artist

Toomsuba, 1973
acrylic on canvas
72 x 72
Collection of the artist

Toomsuba, 1973
colored pencil on paper
12 x 12
Collection of the artist

Cybur, 1975
oil on canvas
72 x 72
Collection of Volvo North
America Corporation
Acquired by Pehr Gyllenhammar

Natchez, 1975
oil on canvas
24 x 24
Collection of the artist

Parchman, 1975
encaustic on canvas
24 x 24
Collection of the artist

Bellefontaine, 1976
oil and metallic pigment on
canvas
72 x 72
Holly Solomon Gallery,
New York, New York

Jackson, 1976
metallic pigment in polymer
emulsion and pencil on canvas
72 x 72
Hirshhorn Museum
and Sculpture Garden,
Smithsonian Institution
Gift of Joseph H. Hirshhorn, 1977

Untitled, 1976
graphite on paper
24 x 24
Collection of Paul Huston
from the estate of Amy Goldin

Big Biloxi, 1979
oil on canvas
80 x 80
Collection of Michael and Juliet
Rubenstein

Pantherburn, 1979
oil and metallic pigment on canvas
96 x 72
Collection of the artist

Big Springs, 1980
gold leaf and oil on canvas
96 x 48
Collection of the artist

Untitled, 1981
oil stick on paper
40 x 24
Collection of the artist

Untitled, 1981
oil stick on paper
40 x 24
Collection of the artist

Arcola, 1982
oil on canvas
81 x 120
Sidney Janis Gallery,
New York, New York

Caledonia, 1982
oil on canvas
72 x 72
Collection of Leonard and
Stephanie Bernheim

Marion, 1982
oil on canvas
20 x 20
Collection of Richard Brown
Baker

Lamont, 1983
oil on canvas
22 x 22
Sidney Janis Gallery,
New York, New York

Tallahatchie, 1984
gold leaf and oil on canvas
80 x 96
Sidney Janis Gallery,
New York, New York

Aquilo, 1985
oil on canvas
54 x 54
Sidney Janis Gallery,
New York, New York

Egremont, 1985
gold leaf and oil on canvas
83 x 115
Sidney Janis Gallery,
New York, New York

Pharsalia, 1985
oil on canvas
72 x 120
Collection of Ellen and
Max Palevsky

Prime, 1986
oil and metallic pigment on
canvas
94 x 94
Sidney Janis Gallery,
New York, New York

Constant, 1988
oil on canvas
72 x 72
Collection of Albright-Knox Art
Gallery, Buffalo, New York
Gift of Seymour H. Knox, 1988

Grade, 1988
oil on canvas
54 x 54
Private collection

Azimuth, 1990
oil on canvas
90 x 138
Sidney Janis Gallery,
New York, New York

Social Contract, 1992
oil on canvas
94 x 94
Sidney Janis Gallery,
New York, New York

Ballets Russes, 1993
oil on canvas
90 x 108
Sidney Janis Gallery,
New York, New York

Untitled, 1994
charcoal and graphite on paper
31 1/2 x 27
Sidney Janis Gallery,
New York, New York

The Best of Everything, 1995
oil and alkyd on canvas
82 x 106
Sidney Janis Gallery,
New York, New York

Run Silent, Run Deep, 1995
oil and alkyd on canvas
72 x 72
Sidney Janis Gallery,
New York, New York

Mississippi Museum of Art
Board of Trustees and Staff

Photography credits

cover, cover flaps, pages 2, 4, 34 (left)—D. James Dee

page 6—Leslie Orr

pages 9 (left), 18, 33—copyright 1995, The Museum of Modern Art

page 9 (right)—copyright 1995, The Barnes Foundation

page 10—David Allison

page 12 (top, bottom)—Eliot Kaufman

page 15—The Brooklyn Museum

page 16—Kunié

page 17—The Aldrich Museum of Contemporary Art

pages 19, 31, 48 (top, middle, bottom), 51, 53, 54 (top),
 60 (top), 61, 62—Richard Kalina

page 22 (top)—Geoffrey Clements, copyright 1995,
 Whitney Museum of American Art

page 22 (bottom)—Wadsworth Atheneum

page 26—courtesy of Joyce Kozloff

page 30—copyright 1995, Whitney Museum of American Art

page 32 (left)—Foto Marburg/Art Resource, NY

page 32 (right)—Alinari/Art Resource, NY

page 34 (right)—courtesy of Cynthia Carlson

page 35—Lee Stalsworth

page 37—Neil Frankel

page 38—photographer unknown

page 40—Patty Wallace

page 41—Beth Maynor

page 44—Gagosian Gallery

pages 49, 54 (middle), 55, 66 (top, middle, bottom),
 67, 68, 69, 70, 71—Ken Showell

page 50—Lee Stalsworth/Ricardo Blanc

page 52—Holly Solomon Gallery

pages 54 (bottom), 56, 57, 58, 59, 60 (middle, bottom),
 63, 64, 65—Allan Finkelman

pages 73, 74, 75, 76, 77—Amos Chan

page 78—John Wetenhall